POSTCARD HISTORY SERIES

New York

NEW ENGLAND INSTITUTE
OF TECHNOLOGY
LIBRARY

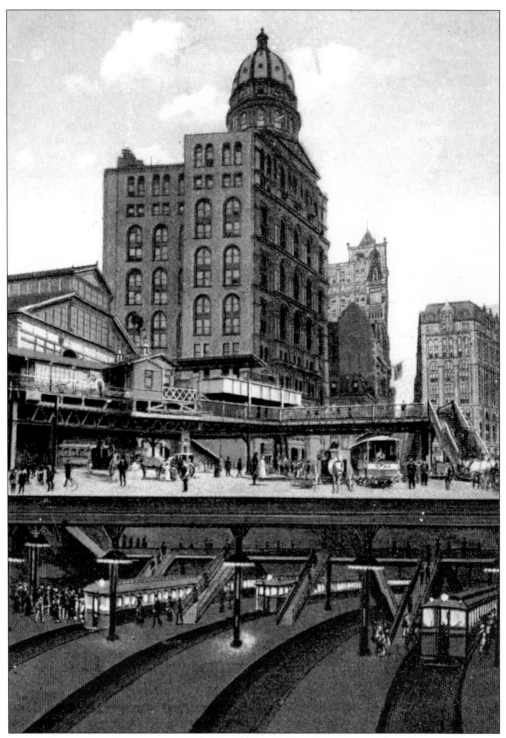

Pictured is an artist's interpretation of the subway tracks and station platforms beneath the shed used as the terminal for surface traffic over the Brooklyn Bridge. The congestion in this area underscored the need for underground mass transportation.

POSTCARD HISTORY SERIES

New York City Subways

Tom Range Sr.

ARCADIA

First published 2002
Reprinted 2004

Published by Arcadia Publishing,
an imprint of Tempus Publishing Inc.
Portsmouth NH, Charleston SC, Chicago,
San Francisco

Printed in Great Britain

Library of Congress Catalog Card Number: 2002108385

For all general information, contact Arcadia Publishing:
Telephone 843-853-2070
Fax 843-853-0044
E-mail sales@arcadiapublishing.com
For customer service and orders:
Toll-free 1-888-313-2665

Visit us on the Internet at www.arcadiapublishing.com

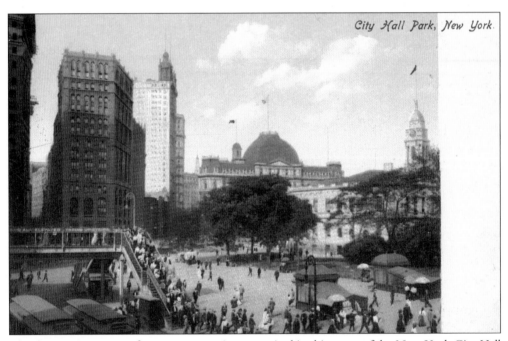

The three major means of mass transportation are united in this scene of the New York City Hall area, looking south. The stairway to the left leads to access to stations of the elevated lines, and surface streetcars are nestled beneath the overpass. Near the cupola-topped New York City Hall are entrance and exit kiosks to the subway system. The domed building is the main post office.

CONTENTS

Acknowledgments 6

Introduction 7

1. Surface Transportation 9

2. The Elevated 19

3. The Subways 37

4. The Hudson Tubes, the City's Other Subway 61

5. Art and Architecture 69

6. Changing Cityscapes 91

7. Transportation Hubs 107

Index 128

ACKNOWLEDGMENTS

Since the passage by Congress of what is known as the Private Mailing Card Act on May 19, 1898, picture postcard publishers have been documenting the engineering marvels associated with the construction and operation of New York City's subway and elevated lines. Most of the early cards bore the artwork and photographs of anonymous artists.

The following are the identified artists whose work have been duplicated on the postcards I have used in this book, all cards being part of my private collection of more than 12,000 New York City views: Berenice Abbott, Seth Allen, Rudy Burkhardt, Cooper-Hewitt Museum, Giorgio Cosulich de Pecine, Robert Disraeli, Todd Dobbins, J. Domingo, Dover Publications, Ralph Fasanella, Andreas Feininger, Grancel Fitz, "Fred," Bob Glander, Gail Greig, Sy Kettelson, Jerome Mallmann, William R. Mangahas, Reginald Marsh, Museum of the City of New York, New York Transit Museum, New York Public Library, R.F. Outcault, Jeff Prant, Steven Shames, John Sloan, Lou Stouman, Carl H. Sturner, John Tauranac, the New-York Historical Society, George Tooker, Julian White, Alan Wolfson, Steve Zabel, and Marty Zimmerman. If the name of any artist or photographer has been omitted, it is unintentional. I, and thousands of picture postcard collectors, are indebted to them all.

My special thanks go to Jaye Furlonger, archivist at the MTA Transit Museum, for her help in identifying objects appearing on the views of early subway stations and platforms.

The els and subways so dominated the cityscape that virtually every illustrated book on New York City published since the 1870s contains at least a handful of representations of the rapid-transit system. In researching the images on my postcards, I am indebted to the authors and publishers of the following: *Interborough Rapid Transit* (1904), reprinted by Arno Press; *Uptown, Downtown* (1976), by Steven Fischer, published by Hawthorn Books; *AIA Guide to New York City* (1988), by Elliot Willensky and Norval White, published by Harcourt Brace Jovanovich; *New York Observed* (1987), edited by Barbara Cohen, Seymour Chwast, and Steven Heller, published by Harry N. Abrams; and *The Man Who Ran the Subways* (1968), by L.H. Whittemore, published by Holt, Rinehart and Winston. I am also indebted to the many works of Dover Publications, including *New York Life at the Turn of the Century* (1985), by Joseph Byron, with text by Albert K. Baragwanath; *New York in the Forties* (1978), by Andreas Feininger, with text by John von Hartz; and *New York Then and Now* (1976), by Edward B. Watson and Edmund V. Gillon Jr.

I extend my gratitude to the dealer-members of the Metropolitan Post Card Collectors Club of Manhattan and to the Washington Crossing Card Collectors Club of Titusville, New Jersey. Without the help of these friends in acquiring these cards, my collection would be all the poorer and this book would never have been written.

INTRODUCTION

Amid the devastation resulting from the terrorist attacks on the World Trade Center on September 11, 2001, was the destruction of portions of the New York City subway system and the PATH service from New Jersey, which terminated beneath the towers. Plans for the reconstruction of the afflicted area include substantial improvements in the rapid-transit system.

New York's system, above and below ground, dates from 1867, when Charles T. Harvey constructed a cable-driven experimental elevated railroad along a quarter of a mile on Greenwich Street on the west side of Manhattan. By 1900, the elevated line had been extended and interconnected to serve virtually all parts of Manhattan and the outlying boroughs of the Bronx, Brooklyn, and Queens.

With the elevated in operation, the pedestrians of the city's streets were relieved of at least some of the surface congestion of omnibuses, trolleys, horse-drawn vehicles, electric- and steam-powered automobiles, and the occasional "gas buggy." They could get from their homes to their jobs, the theater, schools, museums, sporting events, and all the other amenities of urban life quickly in relative comfort and at a cost of 5¢.

The early el trains were powered by steam engines. The pedestrians below were in constant danger of being hit by cinders falling from the coal-fueled locomotives. Occasionally, pieces of the wooden ties and even ironwork rained down upon the stroller below. The rattling of the passing trains shook the dishes of the apartment dwellers along the right of way. The lack of privacy of the dwellers of the apartments along the routes was appalling, as their domestic life was visible to the riders of the passing trains. Clearly, underground rapid transit was considered a necessity as a means of transportation within an urban setting.

New York City's first official subway system opened in Manhattan on October 27, 1904. Operated by the privately owned Interborough Rapid Transit Company (IRT), it extended nine miles up the island from New York City Hall to 145th Street and Broadway. By 1905, IRT service extended north over the Harlem River to the borough of the Bronx. Three years later, service was extended to Brooklyn and, in 1915, to Queens. The Brooklyn-Manhattan Transit Corporation (BMT), similarly privately owned, began service between the two boroughs in 1915. The IRT and BMT, operating under equipment- and route-sharing dual contracts, further united Manhattan with the outer boroughs. A city-owned line, the Independent Rapid Transit Railroad (IND), began operations in 1932. In 1940, by purchasing the two private lines, the city became the sole owner and operator of all New York City subway and elevated lines.

Picture postcards were first allowed in the U.S. mail in 1898. Among the first subjects chosen by publishers to be depicted on New York City cards were the els, then considered one of the engineering marvels of the world. The interests of the publishers carried over to depicting the development of the subways from their construction, which began in 1900. The subways supplemented and then substantially displaced the els as a fast, inexpensive means of getting around the city. The Third Avenue el, the last elevated line in Manhattan, closed in 1955. Images of the subway continue to be a favored subject by the advertising media and for public service messages, such as the Quit Yet? antismoking campaign of the New York City Department of Health. The rapid-transit system itself has used postcards to publicize its Metrocard service, which eliminates the use of coins or tokens to ride the subway.

Interior views of subway stations, platforms, and cars are of particular interest, ranging from the ornate *c.* 1900 station at New York City Hall to the functional but still pleasantly decorated modern stations. Some depictions of the passengers will acquaint the viewer with the vicissitudes of riding the subway, even if many images are exaggerations, meant to poke fun at what is usually a commonplace and uneventful interlude in the life of a New York City resident. From the earliest days, standees in omnibuses, streetcars, els, and subways steadied themselves by grasping onto leather straps suspended from horizontal bars overhead. These riders have forever after have borne the title "straphangers."

The more than 200 images in this book will trace the expansion of the els and subways over the century of their existence. I have kept in my captioning the names of buildings and streets that prevailed within the time frame in which the cards were produced. For example, I have ignored the redesignation of Sixth Avenue as Avenue of the Americas, as have most, with the exception of map makers.

Enjoy the ride.

One
SURFACE TRANSPORTATION

By the mid-19th century, street traffic was a mess. One observer, Elizabeth Oates Smith, remarked in 1854, "There is no getting up nor down the street. There is a dead calm. . . . Passengers thread in and out amid this Babel with wondrous dexterity, now seizing the tongue of a stage, now ducking under the teeth of a horse, mounting a cart . . . zigzagging amid vehicles of every kind. . . . At length far down, a mile off . . . the jam breaks, and the whole mass gives way. . . . All is in motion again."

Nor was river traffic any better. As early as 1836, the *New York Mirror* observed, "It is not pleasant, nor is it safe, to cross a river in a ferry boat crowded with carriages, carts, horses . . . drays, men, women, children . . . all promiscuously huddled together."

What is to be done? A simplistic solution to this dilemma would be to segregate mass transportation from the streets either by elevating rail lines or by digging tunnels under rivers and city streets for the use of railroads—or by a combination of both.

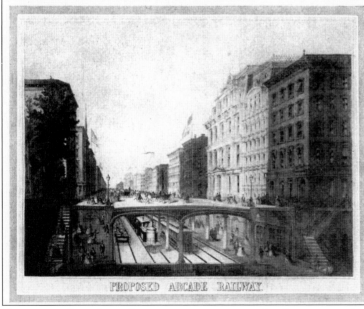

PROPOSED ARCADE RAILWAY.

Broadway, as a double-decker street; Northeast corner of Trinity Church-yard at left. Four-track subway. (Beach Pneumatic Transit Company issued 1872 plan for railway in two tubes. Subway transit was in the air.) From lithograph in Eno Collection, The New York Public Library.

One proposal, as shown here, was to construct pedestrian promenades one or two stories above street level, forcing milady to climb a flight of stairs to embark upon her afternoon constitutional. The idea, however, never got off the ground.

The earliest attempt at mass transportation was the appearance of omnibuses on the city streets. These were basically stagecoaches with seating along the sides of the car, plus some open-air benches on the roof. Passengers entered from the rear. The vehicle would seat six on each side, plus as many standees as could squeeze in. The driver rode outside the coach, exposed to the weather in all seasons. These vehicles were introduced to New York by coach maker Abraham Brower in 1831.

Just as the children of today delight in toy replicas of jet planes or space vehicles, the tots of 1860 were enthralled by replicas of the modern marvel of transportation—the omnibus. The toy coach is painted a brilliant yellow, as were the vehicles themselves. Note the Spartan accommodations of the driver, out in the open with no protection from the elements.

Drawing upon the experience of the use of rails in the mining industry, mass-transit engineers found that a vehicle drawn by an animal on a set of tracks could contain a much heavier payload. The second stage in urban mass transit was the horse-drawn streetcar mounted on tracks, which were first made of wood and, later, of iron.

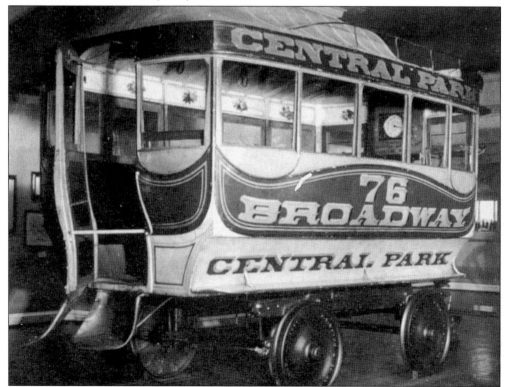

The configuration of the horsecar mounted on rails differed little from its omnibus predecessor. Horsecars operated throughout the city until the electrification program began in the 1890s. (Postcard produced by the Museum of the City of New York.)

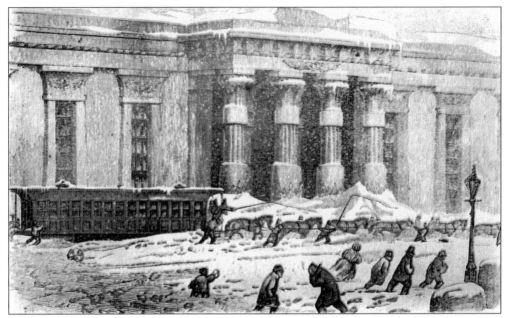

While the horse performed yeoman duty under normal weather conditions, scenes such as this were all too common. A surface car—in this case a coach of the Harlem Rail Road, which was allowed to use the city streets—is being hauled by at least six two-horse teams through blizzard conditions. The building seen here and called the Tombs was the city's major prison, so named for its fancied resemblance to an Egyptian house of the dead.

For all the congestion the horsecars created in the built-up downtown area, they were a godsend in uniting the rural areas uptown to the jobs and stores at the tip of the island. The first streetcars began their run in 1832 on the tracks of the New York & Harlem Railway, on the Bowery between Prince and East 14th Streets. The streetcar line consisted of two horse-drawn cars built by John Stevenson, a coach maker, and could accommodate 14 passengers. They ran every 15 minutes and cost 25¢ to ride. The cars on rails drove the omnibuses off the street completely (except for the very exclusive Fifth Avenue, the residents of which never allowed railed traffic) by 1884.

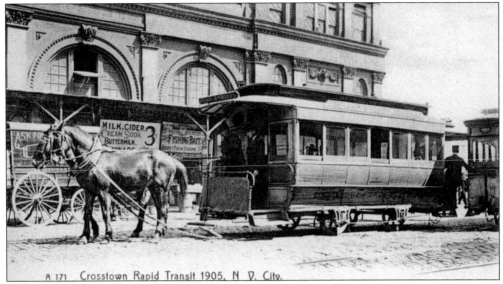

Horsecars served many areas of the city well beyond the start of electrification of the surface systems. It took time to place the conduits containing the power cables between the two tracks. Also, the passengers still had to get to and from their jobs and would not tolerate interruptions in service.

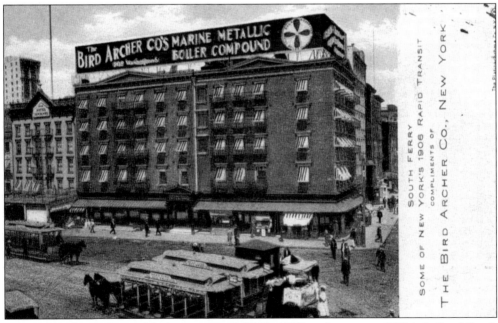

Horsecars gather in front of the Eastern Hotel (1822–1920) at the corner of Whitehall and South Streets. These cars would serve both the guests at the hotel and commuters emerging from the Ferry Depot, located a few steps farther south. This postcard view served as an advertisement for the Bird Archer Company, as indicated by the billboard on the hotel building.

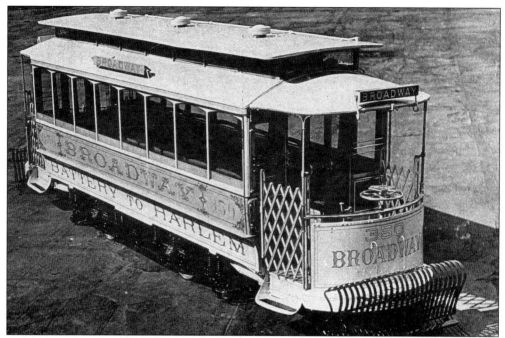

The next step in the development of surface transportation was the installation of a system of cables embedded in the streets between the horsecar tracks. These cables, powered by steam motors, would run continuously beneath the car. A model of a Broadway cable car, among the holdings of the Museum of the City of New York, shows a configuration not unlike the horsecars (but, of course, without horses). The device to grip on to the cable spinning beneath the street is under the car. Note the cowcatcher mounted in front.

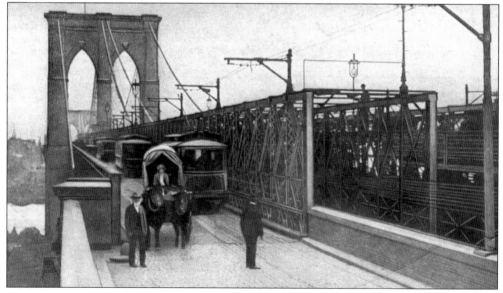

The covered wagon of the historian Ezra Meeker, who made a cross-country journey from Washington State, traverses the Brooklyn-bound vehicular lane on the Brooklyn Bridge. The superstructure supported overhead electric wires for trolley cars. A parade of surface cars lines up next to the ox-drawn wagon.

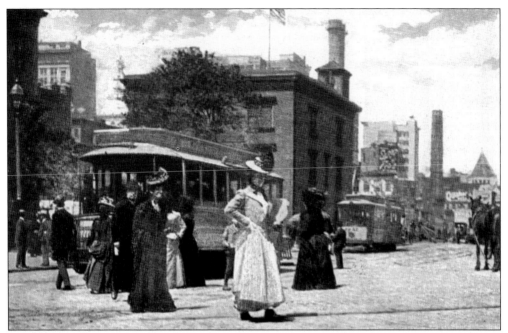

Pretty young ladies emerge from a streetcar stopped near City Hall Park. The three-story building at the northeast corner of the park contained a firehouse at ground level and court offices on the upper floors. The view on this private mailing card looks north on Centre Street.

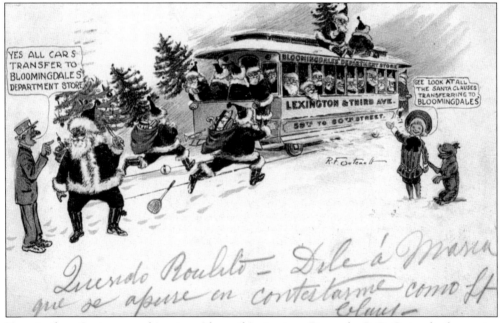

Twenty-three Santas are rushing to a ride on this streetcar. Drawn by R.F. Outcault, the creator of the cartoon character Buster Brown, this 1904 image served as an advertisement for Bloomingdale's department store at East 59th Street, where, according to its slogan, "all cars transfer."

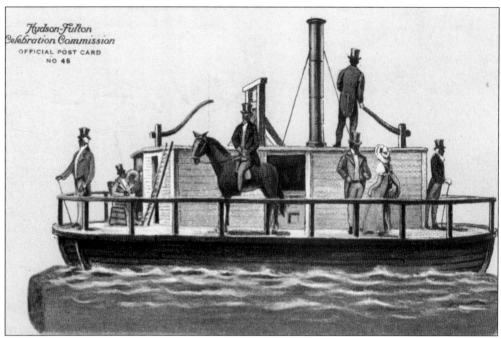

The steam ferry invented by Robert Fulton brought passengers across the Hudson River from Jersey City to Cortlandt Street in about 20 minutes. The line that he established began service in 1812. This view shows a rendition of a float in the 1909 Hudson-Fulton celebration.

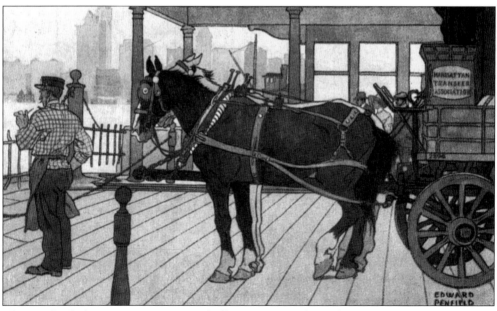

The men's clothing company Hart Schaffner & Marx chose this postcard as an advertising medium. An interior view of a Hudson River ferry discloses a proud two-horse team patiently waiting for the boat to berth. The wagon driver is taking a pipe during the 10-minute ride.

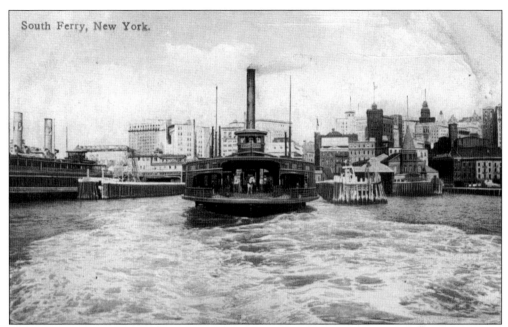

South Ferry, New York.

The reliance of Manhattan upon ferry service is underscored by this view. The traffic appears to be all horse-drawn vehicles. On a foggy day, or in severe snow or rain, lower Manhattan would be isolated.

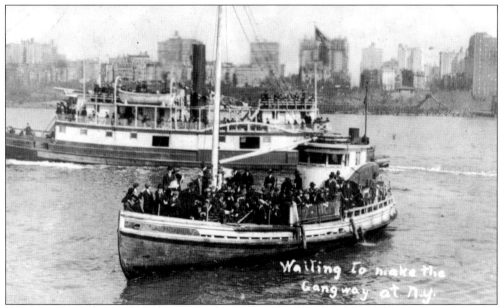

Waiting to make the Gangway at n.y.

With the Hudson River ferries being the only method of reaching Manhattan prior to the completion of the Hudson Tubes, the New Jersey commuter was at the mercy of the elements and the crowded river traffic. This photograph has appropriately been titled by its photographer "Waiting to make the Gangway at N.Y."

The completion of the downtown New York line of the Hudson Tubes virtually eliminated the need for ferries to transport pedestrian traffic. Shown here is the New Jersey entrance to the ferry line to Barklay Street in lower Manhattan.

The destination of the 42nd Street crosstown surface lines was this ferry house on the Hudson River. These ferries connected Manhattan to West New York and Weehawken on the New Jersey side of the river. Paradoxically, ferry service to Weehawken has recently been reinstated.

Two

THE ELEVATED

The first elevated system in Manhattan was developed by Charles Harvey in 1867. It was powered by cables and, initially, extended about a quarter of a mile up Greenwich Street on the west side of the island. The line was extended uptown and converted to steam locomotive power, commencing in 1871. By the early 1890s, there were more than 500 Forney steam engines in service, named after the inventor Matthias Forney.

The coal-fueled steam engines were dirty to operate. By 1903, therefore, all of the city's els were converted to electric power, using engines developed by Frank J. Sprague. The power was delivered to the engine by a third rail, which is tapped by use of a "shoe" extended from the engine. The third rail delivery system is now used throughout New York City's subway and elevated lines.

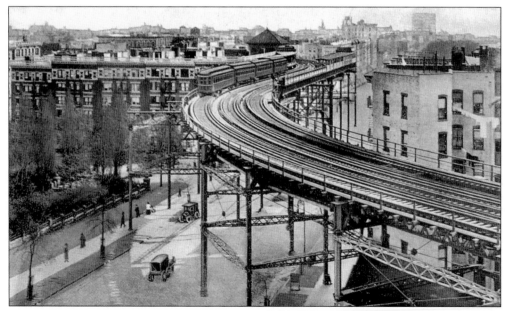

A spectacular curve at West 110th Street was the tallest point on the elevated system in Manhattan. It towered some 60 feet above the sidewalk.

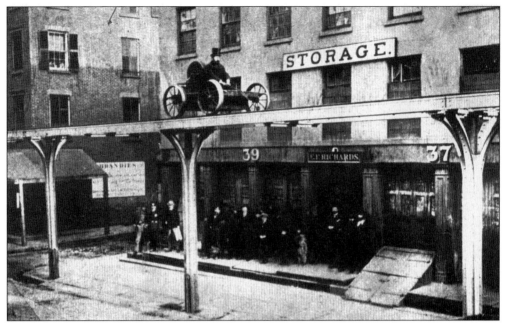

In 1867, inventor Charles Harvey constructed a quarter-mile-long experimental elevated railroad track along Greenwich Street in lower Manhattan. He devised this car, propelled by cables. It is similar to the present-day surface cable cars in San Francisco and to the system of surface cars that dominated Manhattan in the late 1800s. As a result of the political pressure of William M. Tweed, the "Boss" Tweed of New York City politics who had a major interest in surface lines, Harvey's plans for an extensive elevated system failed.

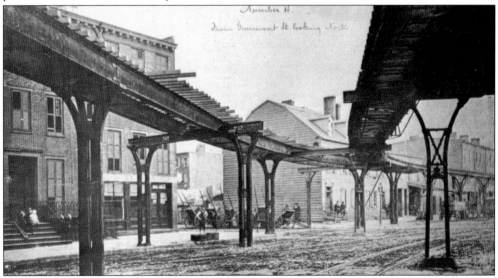

Although Harvey failed in his attempt, the idea of elevated railroads persisted and finally prevailed after Tweed was forced to flee the law. A system for elevated cars stretched up Manhattan for 13 miles, powered at first by cable and then by steam locomotives. This 1876 view shows the el tracks at Gansevoort Street, where the el turned from Greenwich Street into Ninth Avenue. The tracks appearing on the street beneath the two elevated tracks was the right of way for horse-drawn surface cars.

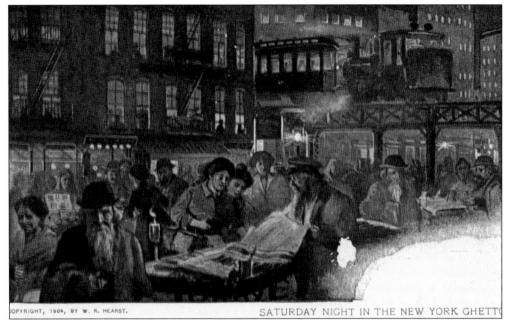

SATURDAY NIGHT IN THE NEW YORK GHETTO

Since the age of postcards started as the els were being electrified, there are few images of the donkey engines that had been used to propel the passenger cars along their sinuous paths. This view, a supplement card (so called because the cards were included free to readers of the Sunday supplements of Hearst newspapers), shows the steam-powered el passing through the Lower East Side.

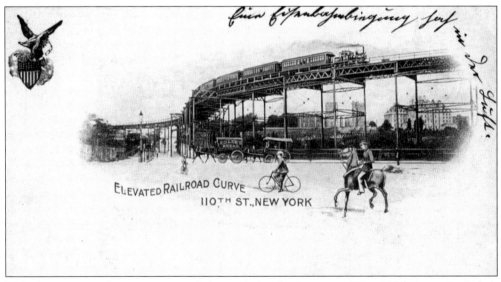

ELEVATED RAILROAD CURVE
110TH ST., NEW YORK

This view portrays the steam-powered el negotiating the S-curve at West 110th Street. St. Luke's Hospital looms up to the right. Note the other forms of transportation in this busy view—the horseman, bicyclist, and horse-drawn delivery wagons.

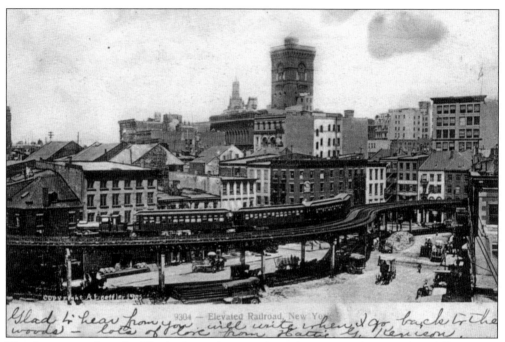

9304 — Elevated Railroad, New York

The S-curve at Coenties Slip is shown in two views that appear the same but differ in one important detail. The view above shows the train powered by a steam engine before the electrification of the line. The view below shows the electrified train negotiating the bend in the track. The tower of the Produce Exchange (1884), situated at 2 Broadway at Bowling Green, is predominant in both views. The building was razed in 1957.

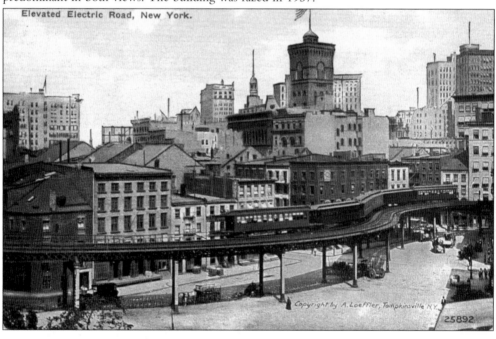

Elevated Electric Road, New York.

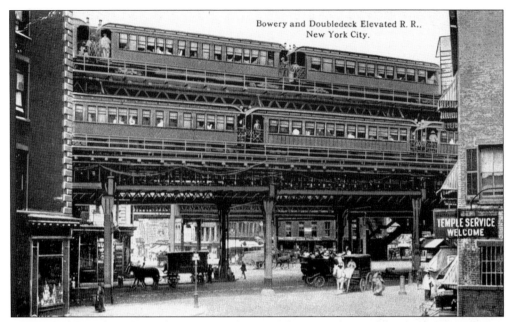

Since 1878, the route of the Third Avenue el crossed the major thoroughfare named the Bowery. Two years later, the Second Avenue el intersected both the existing el and the street. The Bowery was named for the route leading from old New Amsterdam to Peter Stuyvesant's *bouwerie* (meaning "farm" in Dutch).

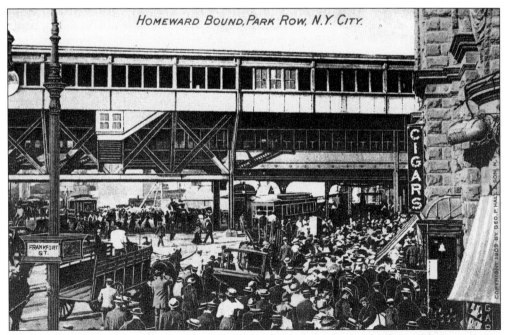

"Homeward Bound" is an eminently fitting title of this 1909 view of office workers streaming toward the subways, els, and streetcars in front of the Pulitzer Building at Frankfort Street and Park Row. Virtually every pedestrian, man and woman, wears a head covering, reflective of this staid, formal age.

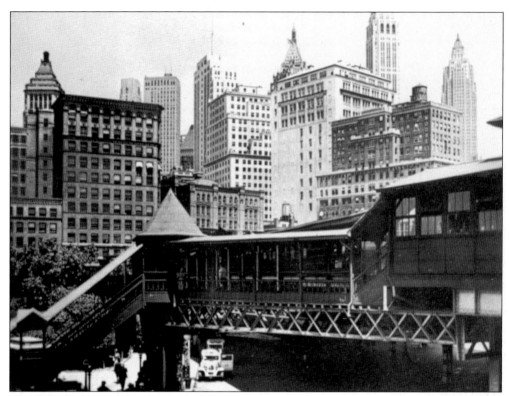

The utilitarian elevated stations, platforms, and staircases were given a touch of class by Jasper F. Cropsey, a renowned painter who designed a number of the stations in the Gothic Revival style. The structures resembled gingerbread cottages, sporting peaked gables, tiny cupolas, and filigreed balustrades.

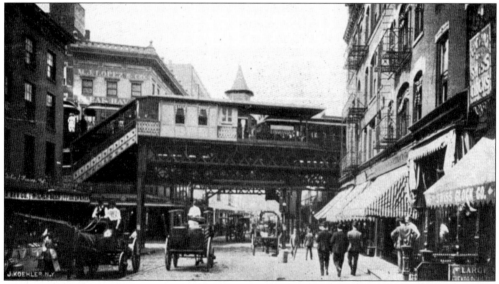

This view of the el station at Barklay Street shows further proof of the graceful architecture prompted by Cropsey's designs. Note the surprising absence of motorcars on this busy downtown commercial street.

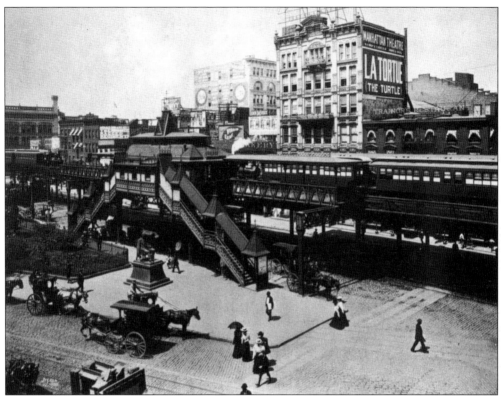

The statue of the seated newspaperman Horace Greeley is dwarfed by the massive Sixth Avenue el station at what is known as Greeley Square, at the intersection of Sixth Avenue and Broadway at West 33rd to 32nd Streets. Note the streets paved with Belgian blocks, with flagstones at the crossings, in this 1896 photograph by Byron from the Museum of the City of New York collection.

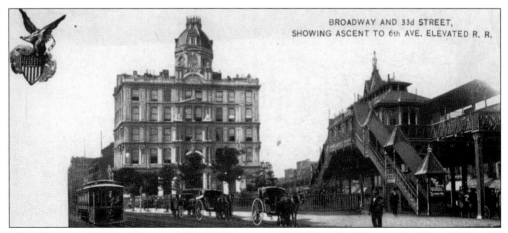

The el station is shown from a different perspective. The large building at the foot of the park housed the Union Dime Savings Bank, erected *c.* 1876.

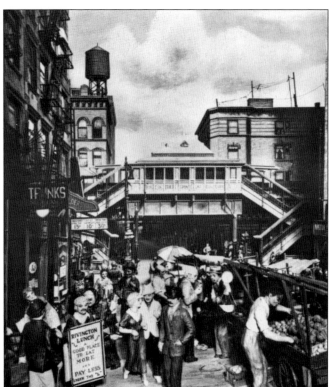

The Museum of the City of New York included a replica of an el station in its diorama entitled "Push Cart Market."

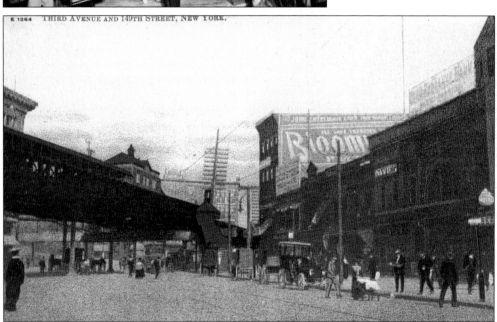

An elevated station in the Bronx appears in this view. Note the utility pole with 10 crossarms bearing telephone and telegraph wires, plus the lone automobile at the curb. In lower Manhattan, the Blizzard of 1888 prompted the city administration to require most utility wires to be placed underground. Trolleys, with their overhead wires, were a rarity in Manhattan, being banned below 125th Street.

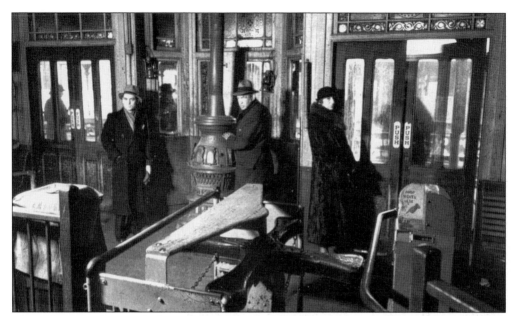

This 1936 view by noted photographer Berenice Abbott captures the bored expressions of el riders waiting for their train. A man warms his hands at the station's potbellied stove. The familiar turnstile entrance shows a hand image that indicates the slot for the nickel fare. The station's interior waiting rooms contained artful woodwork and tinted-glass windows. The 5¢ fare prevailed for 44 years, until 1948. It cost 10¢ to ride the system until 1953. A 15¢ token got you on the train until 1966, and the rate then became 20¢. Today, it costs $1.50 for a ride.

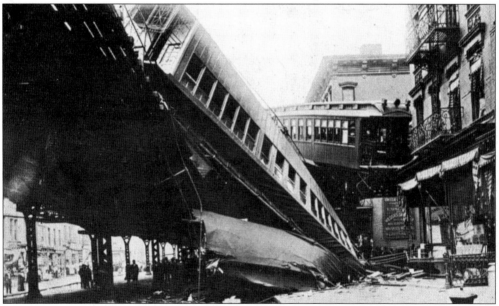

Although the safety record of both els and subways is phenomenal (considering the thousands of operating hours the lines experience running round the clock seven days a week), accidents do occur. This view shows the derailment of two Ninth Avenue el trains in September 1905. The els, being prone to weather conditions, are more apt to have equipment failure and track deterioration than their below-surface counterparts.

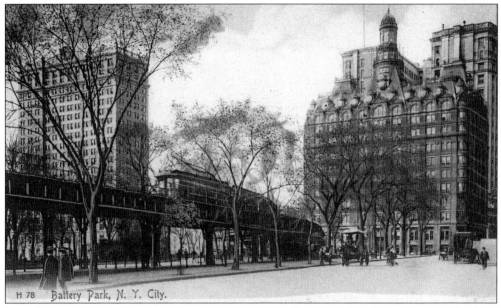

This section of the el represents an extension of the line from Bowling Green to the ferry complex at South Ferry. Its route skirted Battery Park. The Whitehall Building (1910) rises at the left, and the towered Washington Building (1884), at 1 Broadway, soars at the right.

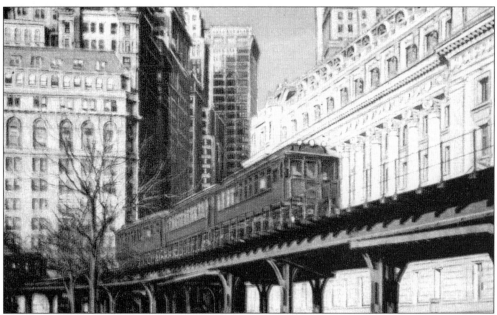

The South Ferry spur is shown from just inside Battery Park. The Washington Building is at the left. The train passes the Beaux-Arts architecture of the side of what is currently named the Alexander Hamilton Custom House, constructed in 1907, after designs by Cass Gilbert.

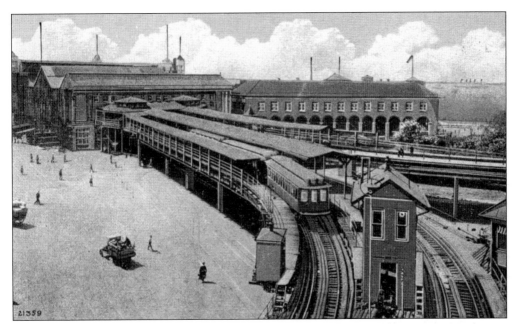

This maze of el tracks and stations was at South Ferry, the southernmost location on Manhattan. The ferry houses, with boats connecting Manhattan to Brooklyn and Staten Island, represent $3 million worth of steel, copper, and glass.

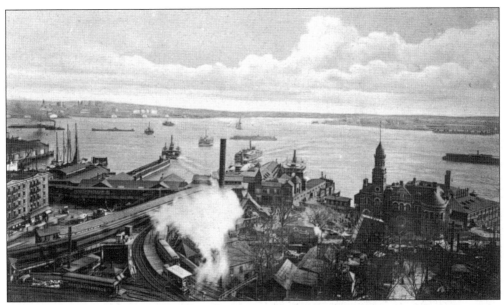

This panoramic view of the South Ferry complex shows a portion of New York harbor. The towered building to the right of the ferry terminals was known as Immigrant Landing, a federal government facility used for the reception and processing of immigrants who had gone through the rigors of inspection on Ellis Island.

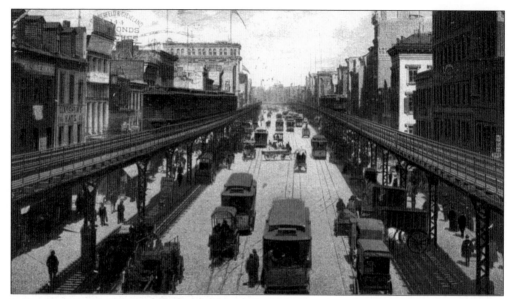

Early el designs placed the tracks along the curb line, pitching the sidewalks into perpetual gloom. On the street level, the Bowery contained three sets of streetcar tracks. The cars were powered by electricity flowing through cables encased within conduits between the tracks.

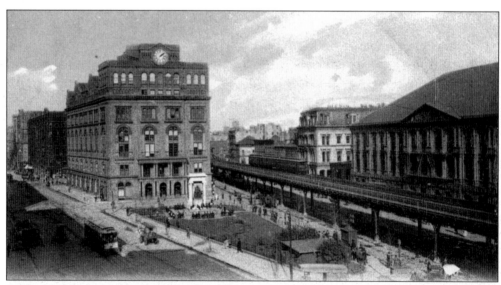

As the Third Avenue el made its inexorable march up Manhattan Island, it passed by Cooper Union at Astor Place. This seat of learning was founded by inventor–industrialist Peter Cooper in 1859 and was the site of a February 1860 speech by Abraham Lincoln. The speech was a key factor in his winning the Republican Party's nomination as its presidential candidate. A monument to Peter Cooper, by Augustus Saint-Gaudens and Stanford White, is situated in the triangular park area.

As equal in importance as getting men (and some women) to their jobs was getting the women (and some men) to the department stores in the shopping district stretching along Sixth Avenue from West 14th to 34th Streets. The el passes by the stores of Simpson-Crawford (1900), the twin domed Hugh O'Neill (1875), Adams Dry Goods (1900), and Ehrich Brothers (1889)—arrayed from 19th through 23rd Streets on the west side of Sixth Avenue.

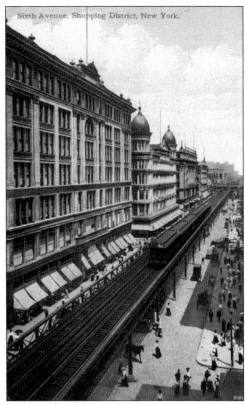

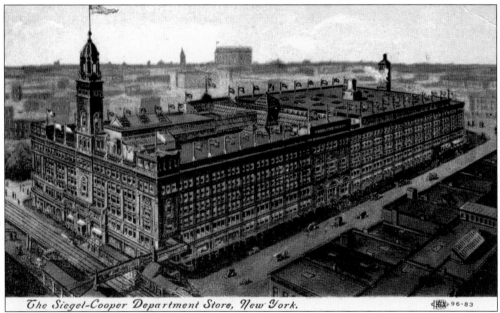

The Siegel-Cooper Department Store, on the east side of Sixth Avenue between 19th and 20th Streets, was constructed in 1896. During World War I, it was converted to a military hospital. Note the artist's conception of an overpass leading directly from an el station into the building. The building survives as a television studio.

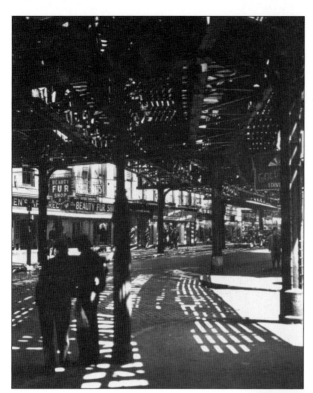

Another Berenice Abbott photograph captures the perpetual shadows cast by the overhead tracks of the els. Although the contrasting blacks and whites make a poignant photographic study, the constant gloom beneath the rails hastened the concept of an underground railway system.

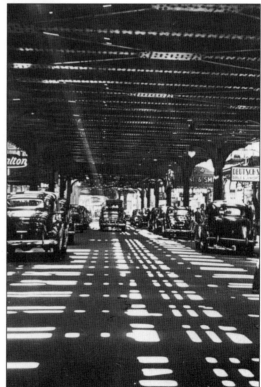

Ninth Avenue at West 110th Street looked liked this in the 1940s, as photographed by Andreas Feininger and reproduced by Dover Publications in 1984.

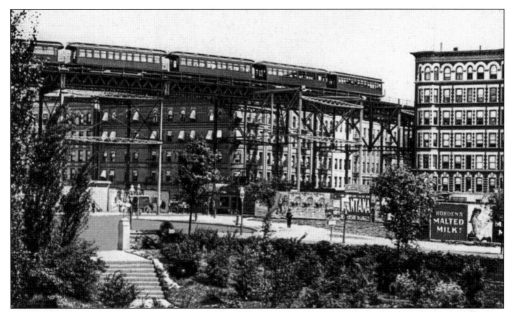

The highest point of the el system in Manhattan was at West 110th Street at Morningside Park, where the tracks made another spectacular curve. Note the billboard featuring an advertisement of Borden's Malted Milk to the lower right.

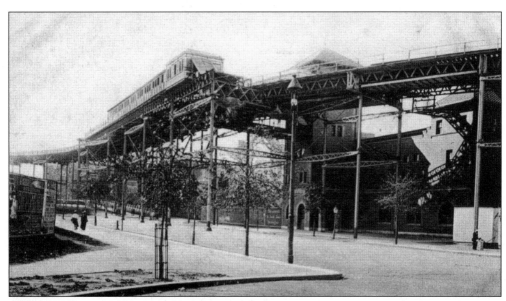

Perched more than 60 feet above the street, the station was accessed by an elevator contained within the brick tower at the center right. The right of way proceeded up Eighth Avenue north of the curve. This line, which opened in 1879, was torn down in 1940.

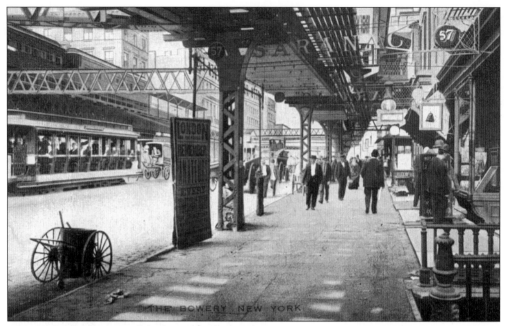

This is a sidewalk view of the Bowery el on a summer's day. Note the open-air streetcar, a ride on which was generally the only breath of fresh air that the dwellers of the Lower East Side could afford. Although the streets were free of the overhead tracks in this period, the sidewalks were in constant shadow.

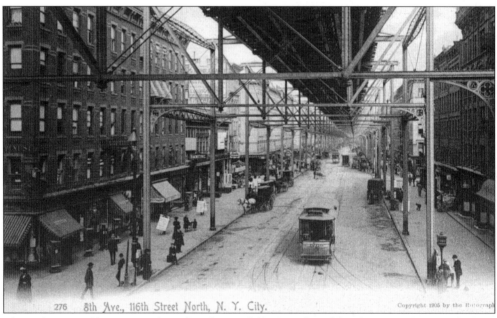

The technique of buttressing the right of way of the central tracks is shown in this view looking up Eighth Avenue. Note the complete absence of motor vehicles. Men carrying sandwich signs are seen on the sidewalk to the left.

Downtown skyscrapers loom up behind the el as it makes another serpentine loop in lower Manhattan. The pyramid-topped building is 40 Wall Street (1929), originally Bank of the Manhattan Company. Its neighbor to the right is 60 Wall Tower (1932), formerly the Cities Service Building.

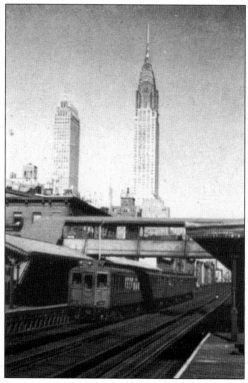

The Chanin (1929) and Chrysler (1930) Buildings punctuate this scene of the Third Avenue el tracks approaching East 42nd Street. Generally, both the el and subways had four sets of tracks (two for uptown trains and two for downtown), the inner tracks being used for express trains. This view shows a downtown express passing a local stop south of 42nd Street.

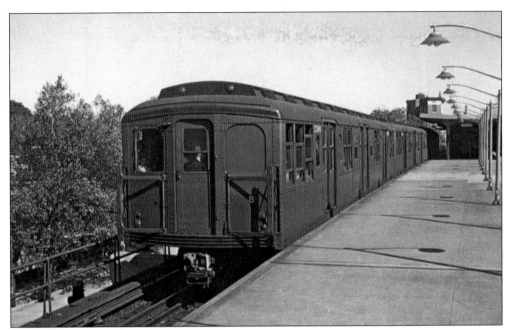

The motorman's cab is to the left. The window on the central storm door was the favored perch of generations of children who would be glued to its window, being told by their parents to "help the driver steer the train." (Photograph by Carl H. Sturner.)

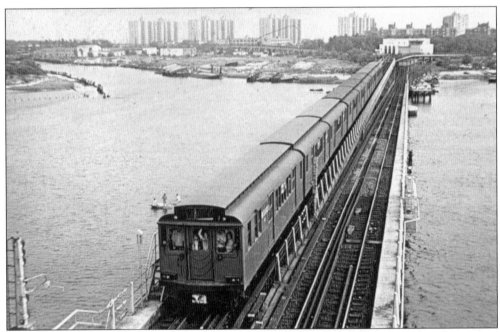

The cars on this train were known as triplex, or articulated, cars. Produced in the 1920s for the Brooklyn–Manhattan Transit Corporation, three cars shared four trucks, or sets of wheels, for greater flexibility in rounding curves. These cars ran on Brooklyn routes until 1965. (Photograph by Steve Zabel.)

Three
THE SUBWAYS

Inventor Alfred Ely Beach envisioned and, in 1870, actually constructed an underground pneumatic railroad along a short block, a little over 300 feet, on Broadway across from City Hall Park. A cab was blown through the lined tunnel by a powerful fan. To make the return trip, the fan was reversed and the cab was sucked back to the ornate station. Beach could not find a financial backer for this venture.

The financier August Belmont organized the first electric-powered subway system modeled upon and avoiding the shortcomings of European systems. The first underground rail system in the world was constructed by tunneling in London in 1863. Steam engines were used as motive power. As can be imagined, it was noisy and dirty. Other European cities followed, with Boston, in 1897, being the first American city to operate a subway. New York began constructing its first subway line in 1900, using the cut-and-cover trench technique used in the construction of the Budapest subway in 1896. New York also borrowed from the Hungarians the idea of structures protecting the subway stairs—the kiosk, the word Americanized from *kushk*. The Manhattan Interborough Rapid Transit collected its first 5¢ fare on October 24, 1904. Service to Brooklyn by tunnel under the East River began in January 1908.

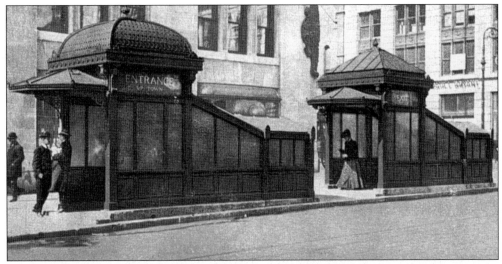

Cast-iron and wire-glass kiosks marked the entrances and exits of the IRT system. They sprouted like mushrooms following the line's progression uptown. This set was located at East 23rd Street. The domed top indicated the entrance staircase; the pyramid was the exit. The kiosks were produced by Hecla Iron Works of Brooklyn, the firm that also produced eight of the ornate el stations. The structures were torn down over the years. The reasons cited were that access was blocked by the homeless who used them as protection from the elements and that they impeded the view of the motorists on the street.

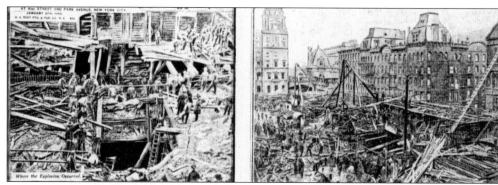

The digging of the IRT was not without its hazards. On January 27, 1902, powderman Moses Epps lit a candle at lunchtime within the tunnel under Park Avenue at East 41st Street. The open flame ignited his lunch wrapper and then spread to a shanty filled with dynamite. Hotels adjoining the route of the tunnel were shaken by the severity of the resulting blast. When the dust settled, 5 people had been killed and more than 180 injured. Ironically, Epps received only minor bruises, and the tunnel endured the explosion with only superficial damage. The digging went on.

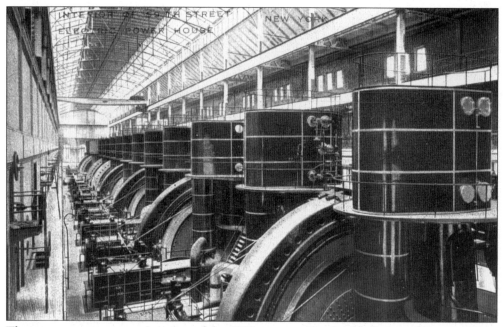

The enormous power requirements of the IRT were met by the installation of huge turbines, pictured here in the powerhouse located on the block bounded by West 58th and 59th Streets and 11th to 12th Avenues, on the Hudson River. The turbines were powered by coal delivered by barge to riverside.

A 1912 action scene shows the cut-and-cover construction process, with rays of sunlight from the open top of the trench illuminating the activity beneath the surface. This image is from the New York Transit Museum archives.

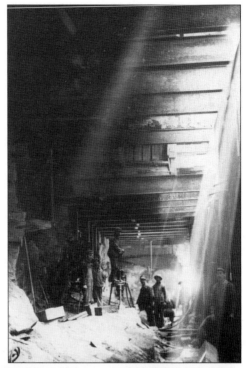

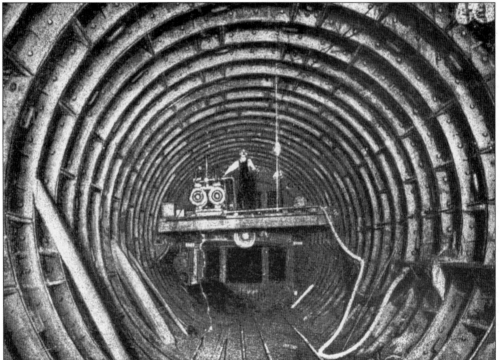

The construction of the first subway tunnel under the East River to Brooklyn was completed in 1908. The route ran from Bowling Green near the tip of Manhattan to Brooklyn Borough Hall. This card, postmarked in 1906, shows the tunnel under construction.

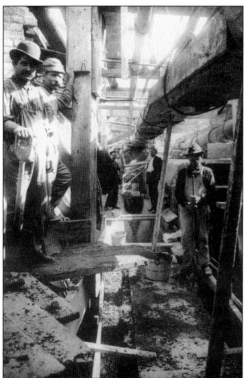

Cut-and-cover work continues under Columbus Circle at West 59th Street and Broadway in this view from the archives of the New York Transit Museum. Note the difficulty in having to shore up sewer and water mains and utility line conduits as the construction crews burrowed underground.

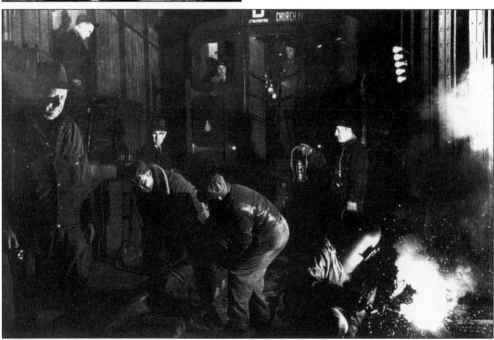

The underground system demands constant attention in serving the millions who ride it every day. In this image from the New York Transit Museum archives, a maintenance crew repairs the tracks on the D line. Experienced riders could identify the D train as being on the IND Sixth Avenue line.

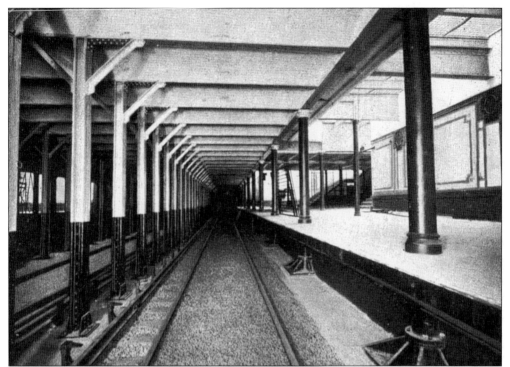

The results of the cut-and-cover construction method are illustrated on this card postmarked 1910. The massive cast-iron pillars support the ceiling and perhaps even the buildings under which the subway runs. The pillars and platform are further supported by footings bedded on cement. The station pictured was the 18th Street IRT before its opening in 1904. It was closed in 1948.

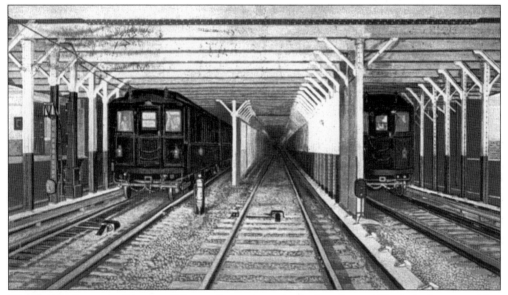

The devices between the sets of the tracks appear to be brake trippers. If a train is approaching too fast, its brakes are automatically applied by the tripper. The offending motorman had to climb down onto the tracks to reset the tripper.

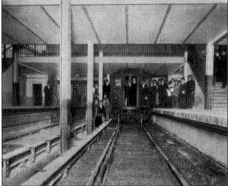

This split-view card shows the interior of the station at the Brooklyn Bridge (lower view). A major portion of the subway system was constructed using the cut-and-cover technique. Topography permitting, trenches were dug along the right of way. Tracks and platforms were installed, and the cut was covered by steel plates. When practical, as the construction work proceeded, plates covered the cut to allow vehicular traffic to pass overhead unimpeded. The building in the upper vignette is the Hall of Records (1902) on Chambers Street. (Courtesy of George T. Guzzio.)

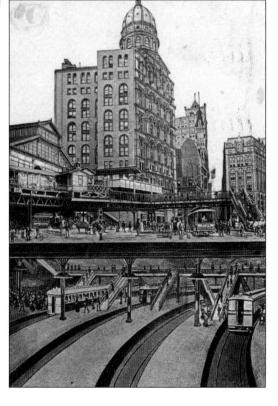

Another image of the important Brooklyn Bridge station shows, in the lower view, the cars at the local platform. The upper view shows, at left, the enormous barnlike elevated railroad terminal at the foot of the bridge as well as the domed New York World newspaper building (destroyed in 1955) and, at right, the New York Times Building, which is now occupied by Pace University.

The venerable New York City Hall (1811), designed by Joseph Mangin and John McComb Jr., and its adjacent park appear in the upper vignette of this split view. The pristine subway station is seen in the lower view.

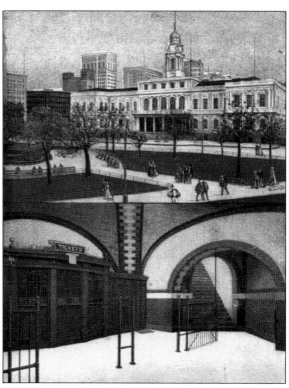

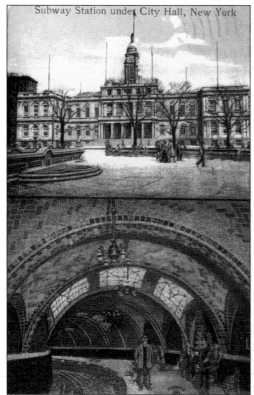

Subway Station under City Hall, New York

The artist emphasizes the grandeur of the New York City Hall loop by including chandeliers lighting the platform. The bulbs used in illuminating the system are threaded in reverse of an ordinary light bulb to discourage pilferage.

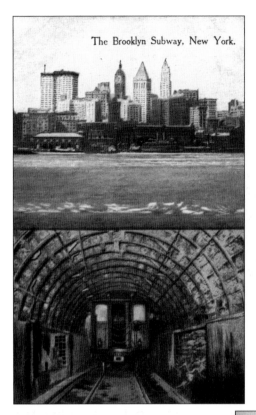

The Brooklyn Subway, New York.

Seen here is an interesting juxtaposition of the ferry terminals at lower Manhattan and an interior view of the recently completed Brooklyn tunnel. The completion of the tunnel caused a reduction of the ridership on the ferries, which had often been immobilized due to weather conditions.

The artist has combined a busy view of New York harbor, showing a departing steamship passing the Statue of Liberty, with his conception of the completed tunnels under the East River linking Manhattan and Brooklyn.

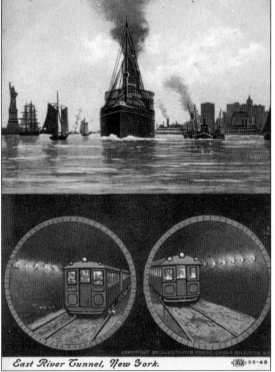

East River Tunnel, New York.

44

Kiosks mark the location of the Bleecker Street station below the street. The Subway Tavern, believe it or not, was opened under the auspices of Henry C. Potter, the Episcopal bishop of New York. The cleric opened it in 1904 "as a club where a respectable workingman could take his family." Although less genteel establishments shut down from the competition, the novelty of a church saloon wore off after a year, and the tavern closed.

A busy street view shows the subway kiosks at the southeast corner of East 23rd Street and Fourth Avenue, known now as Park Avenue South. The corner building housed the Society for the Prevention of Cruelty to Children. Surface cars, powered by electricity since 1898, appear on both streets.

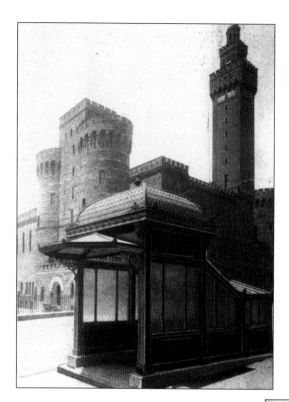

The 71st Regiment Armory serves as a backdrop for this kiosk, which was located at Park Avenue at East 33rd Street. The armory, with its tall Italianate tower, was built in 1904 and was torn down in the 1970s for a multiuse building at 3 Park Avenue.

The kiosk was such a recognizable structure that the Vanderbilt Hotel used it on an advertising piece. What appears to be a handwritten message on the back of this postcard was, in fact, imprinted by the hotel, which made the card available to its guests. The hotel building was converted into offices in 1967.

A damsel poses prettily in this street scene, with a subway entrance serving as a backdrop. This is an example of a romantic postcard, used to keep in touch with friends before the widespread availability of telephones.

Cavanagh's Restaurant, on West 23rd Street, chose a number of typical New York City scenes as advertising pieces, a subway kiosk among them. Note the horsecar in the background.

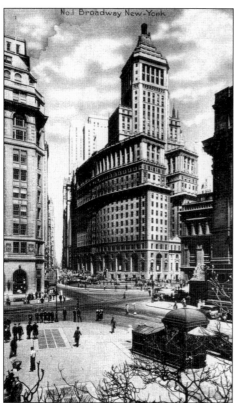

This street scene of the tip of Manhattan shows an entrance kiosk in prominence. The bare trees to the lower left are in Battery Park. The prominent skyscraper is 26 Broadway, built in 1922 as the headquarters of the Standard Oil Company. The statuary and building to the right are part of the U.S. Custom House at Bowling Green. The building now houses the National Museum of the American Indian, a facility of the Smithsonian Institution.

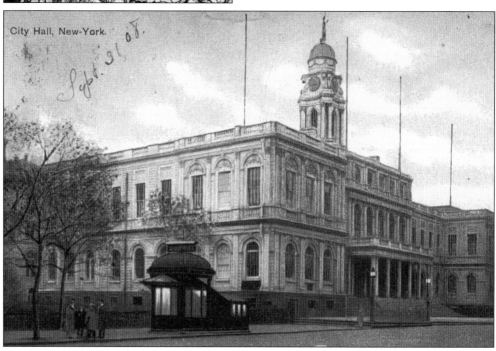

This kiosk, within the shadow of New York City Hall, leads to the subway loop beneath the environs of the building.

Not all of the ornate kiosks were razed over the decades. This one, built of masonry, still exists at West 72nd Street and Broadway. At this point, Broadway is divided by a central mall. The kiosk did not present a hazard to surface traffic, and so it was allowed to remain. This architectural gem was designed by Heins & La Farge in Flemish Renaissance style. The Hotel Ansonia, with its two domed turrets, looms up behind the kiosk.

A similar kiosk is situated in the mall on Broadway, serving the Barnard College campus at West 116th Street. This postcard is a product of the 1930s, the linen era of postcard production, during which the cardboard stock has a fabric-like texture to the touch.

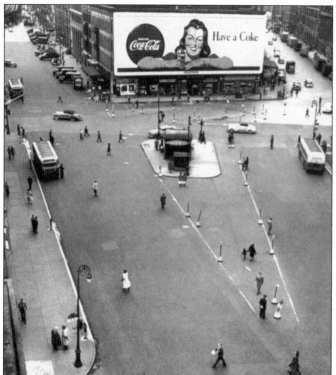

The kiosk at the Astor Place subway station stands in solitary splendor in this 1948 photograph by Rudy Burckhardt. Disregarding their historic and aesthetic value, the Metropolitan Transportation Authority caused to be dismantled all of the original Heins & La Farge–designed IRT kiosks.

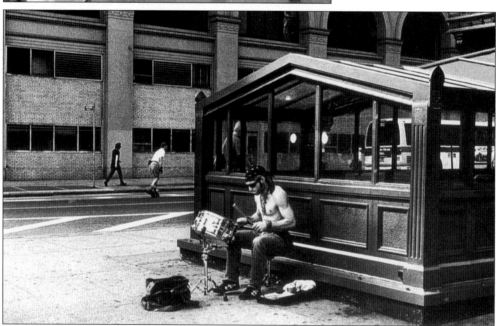

In 1985, to make amends for the destruction of the original cast-iron kiosks, the Metropolitan Transportation Authority had reconstructed a replica, using the forms supplied to the Hecla firm more than 80 years earlier. The replica stands at Astor Place. This 1995 photograph by Jerome Mallmann shows a street performer set up to the rear of the subway entranceway. Notice the skater zipping along Fourth Avenue.

Replacing the destroyed kiosks are these utilitarian staircases leading down to the subway platforms. Virtually devoid of ornamentation, they bear information on what lines are served by the station, plus one or more advertising posters, a source of revenue for the Metropolitan Transportation Authority. Spikes ring the enclosures to discourage people from sitting over the open staircase.

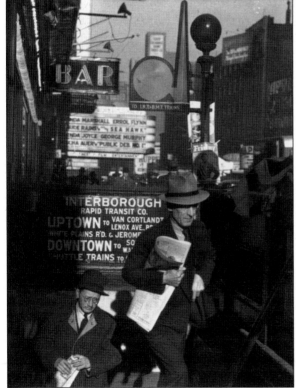

Passengers emerge from a subway station, probably in the Times Square area. This 1940 photograph by Lou Stoumen is titled "Going to Work." Note the Trylon and Perisphere sign mounted on the globe stanchion, indicating that the 1939–1940 World's Fair, held in Queens, was still in progress.

51

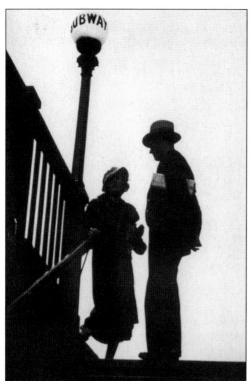

"I'll meetcha at the subway" might be an appropriate caption for this 1940s photograph by Robert Disraeli. The globe atop the stanchion reads just, "Subway." Over the decades, the globes indicated by shape, color, or writing the line being served (the IRT, BMT, or IND) or whether the change booth on the platform was staffed.

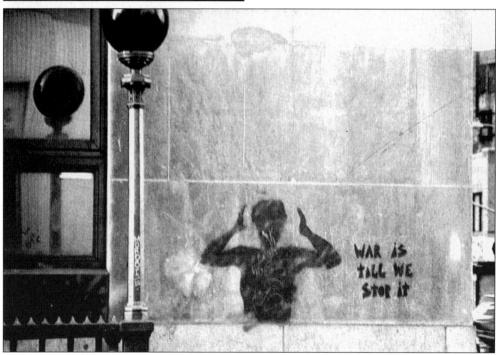

Antiwar graffiti mars the building behind the subway stanchion. The globe atop the stanchion is colored red, indicting that there is no token agent on duty, so the rider had to have at least one token in his pocket to get through the gates. (Photograph by J. Domingo.)

An anonymous violinist hides behind a platform pillar of the Times Square station. The station markers, fashioned of enamel on metal, bear the scars of being located at one of the busiest stations in the system. (Photograph by Giorgio Cosulich de Pecine.)

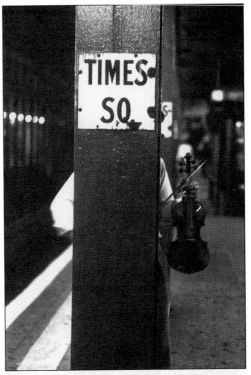

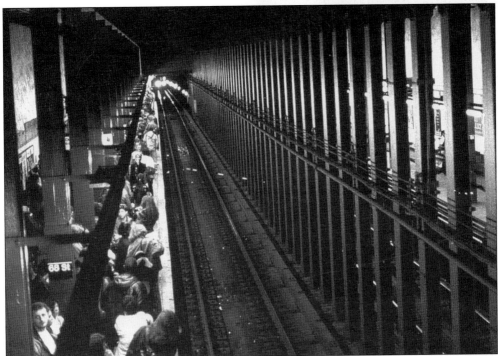

A rush-hour crowd awaits the arrival of the downtown No. 6 train in this typical workaday scene. Most of the riders would be craning their necks, peering up the tracks as if their combined ocular power could draw the train to their station. (Photograph by Jeff Prant.)

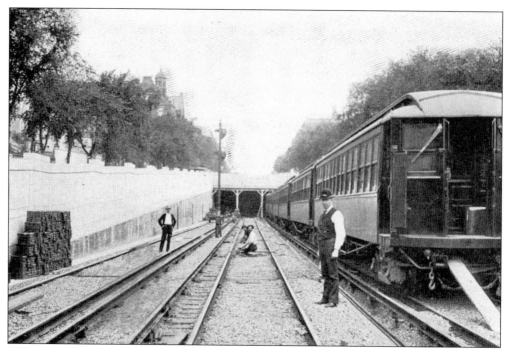

This train appears to be in use temporarily as a work train, with the crew momentarily posing for the photographer. Riders unfamiliar with this section of track are pleasantly surprised by the few moments of daylight on their trips along the northbound and southbound routes.

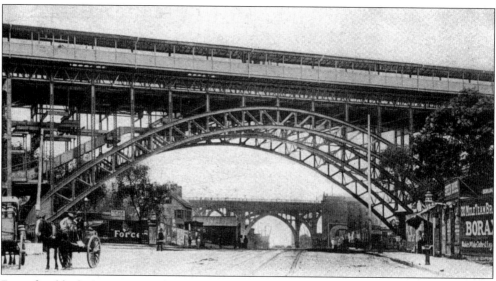

For a few blocks in upper Manhattan, from 122nd to 135th Streets, the IRT subway emerges from the ground and crosses a deep cut in the topography of the island at West 125th Street. This graceful viaduct, constructed in 1904 and designed by William Barclay Parsons, carries the tracks over the street. Farther west, a similar viaduct, used for railroad traffic, can be seen.

Vintage Lo-V (low-voltage) subway cars are driven on a special excursion along elevated lines in Queens. These cars are painted in the original olive and black colors of the IRT line. (Photograph by Carl H. Sturner.)

This display of new and old rolling stock shows an R-110A train (left), built by Kawasaki in 1992, and an R-110B train (right), built by Bombardier of Canada. A venerable Lo-V train, recently restored, appears on the surface-level track. (Photograph by William R. Mangahas; published by Newkirk Images.)

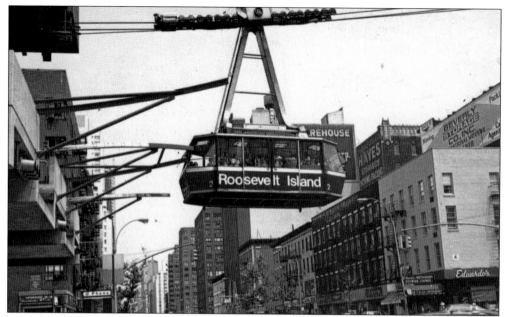

Roosevelt Island (formerly Welfare Island and, before that, Blackwell's Island), in the East River, was developed for residential purposes in the 1970s. A convenient means of transportation from Manhattan to the island is the tramway. Shown here is a cabin leaving the Manhattan terminal at East 60th Street and Second Avenue. (Photograph by Bob Glander.)

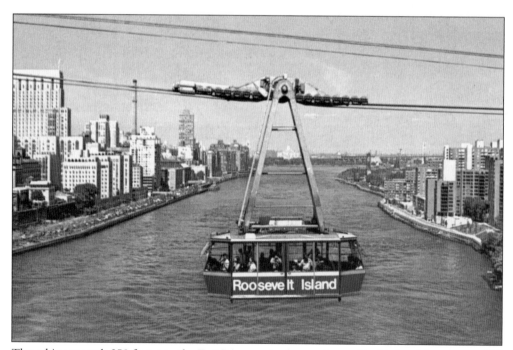

The cabin proceeds 250 feet over the East River on its three-minute ride. Each cabin can carry 125 passengers back and forth from their homes on the island to their jobs and shopping in Manhattan. The tram is now an integral part of the transit system. (Photograph by Graphic Gallery.)

One of the most disruptive peacetime events in New York City history occurred during a two-week period in January 1966. The Transportation Workers Union, headed by Michael Quill, struck the city's transit system. Not a single piece of equipment of subway and surface transportation moved.

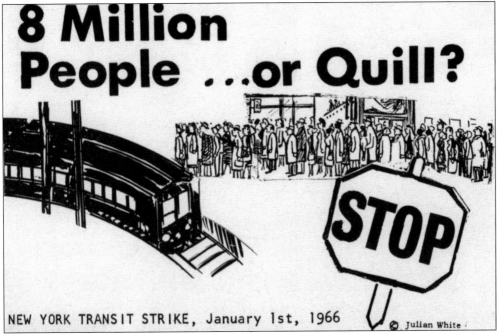

Quill, a lifelong union organizer, called the strike at the stroke of midnight on January 1, 1966, when the two-year union contract with the city was up for renewal. It was estimated that during each day of the strike, more than $100 million in business was lost, with hundreds of thousands of riders either immobilized or forced to use alternate means of transportation to get to their jobs. (Artwork by Julian White.)

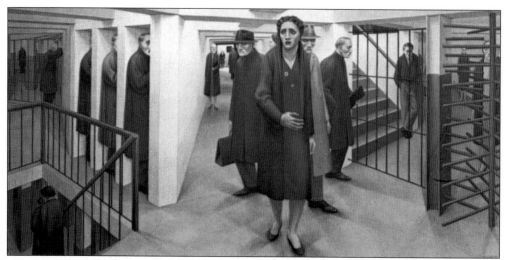

Artist George Tooker envisions on canvas the sometimes justified fear and foreboding of the subway passengers. Considering the tens of thousands of riders carried on the transit system each day without incident, the artist's impression is exaggerated.

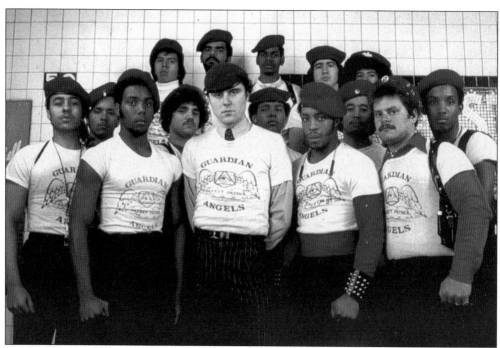

On certain lines and at certain times of the day, the atmosphere on the subways and els can get a bit tense. As a voluntary civilian force formed to discourage unsavory acts in the subway cars, the Guardian Angels patrol the lines that experience a high degree of crime. These young men, wearing red berets and distinctive shirts, have no police power, but they can restrain offenders and, just by their presence, discourage acts of violence. (Photograph by Steven Shames.)

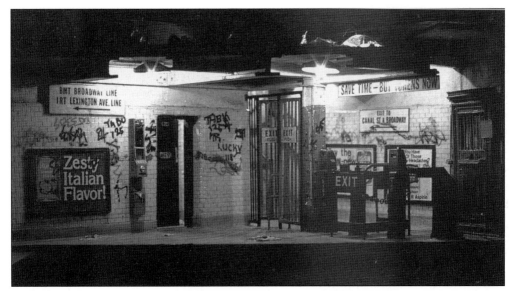

Graffiti, the defacement of public places, began as a form of social protest in the 1960s. Artist Alan Wolfson depicted a platform when the evidence of graffiti was at its height. Amid the defacement, however, this view contains a glimpse of objects familiar to any subway rider. From left to right are panel advertisements on the walls, a dispensing machine (perhaps for gum or tiny candy bars), a door opening into a storage area or toilet, the familiar wooden exit gates, the token-operated entrance turnstiles, and the wooden token booth. The sign over the turnstiles reads, "Save Time—Buy Tokens Now."

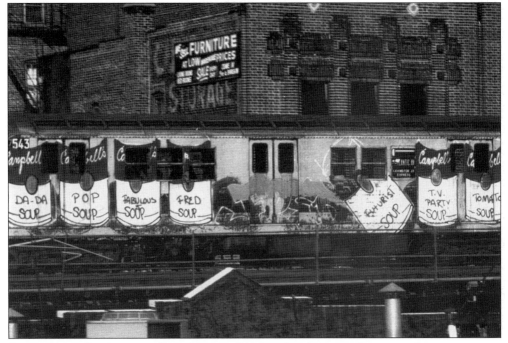

Some groups of artists were allowed to use abandoned and soon-to-be-scrapped cars as canvases for their artwork. This progression of Campbell soup cans is the product of the artist painting under the name, or tag, Fred.

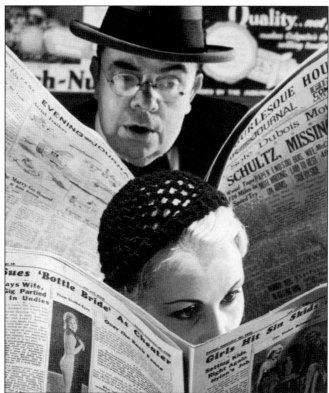

Two avid readers check out the latest news as their train speeds them to their destinations. Folding the newspaper in the rush-hour crowds, and still being able to read it, is an acquired art of the straphanger. This 1932 advertising photograph was taken by Grancel Fitz.

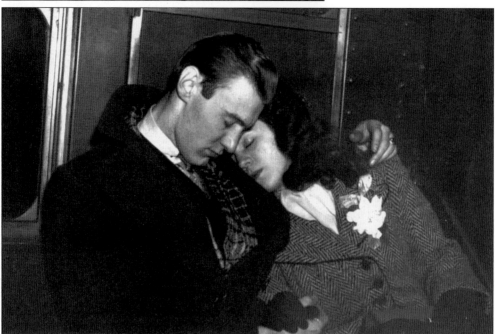

On evenings and weekends, the trains generally belong to the pleasure seekers. Entitled "Going Home on the Subways," this delightful view of a young couple was captured by photographer Lou Stoumen in 1940.

Four

THE HUDSON TUBES, THE CITY'S OTHER SUBWAY

As early as 1879, a plan for passenger trains to operate in a Hudson River tunnel connecting New York with New Jersey was conceived by DeWitt Clinton Haskin. Work on the tunnel progressed sporadically under various managements until 1901, when William Gibbs McAdoo organized the Hudson and Manhattan Railroad. Its first set of tubes connected Hoboken with Christopher Street in the Greenwich Village section of Manhattan and was then extended to West 19th Street. This line opened on February 25, 1908. The line was later extended to the retail shopping district clustered around Herald Square at West 34th Street. Another set of tubes, connecting points in New Jersey with downtown Manhattan, was opened on July 19, 1909.

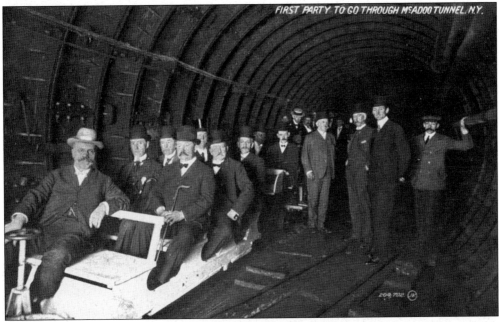

Dignitaries get a tour of the completed McAdoo tunnel under the Hudson River. The tunnel is named after Williams Gibbs McAdoo, the lawyer-financier who organized the Hudson and Manhattan Railroad in 1901 and served as its president for over a decade.

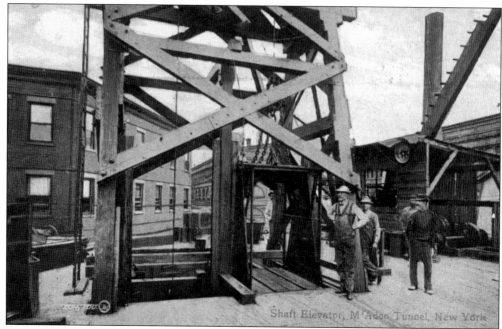

The construction of the Hudson Tubes progressed concurrently with the IRT. Sandhogs on both sides of the Hudson River were delivered to the construction site by means of elevators such as the one pictured. During the workday, railroad carts filled with the excavated debris were hauled up to the surface on these elevators for disposal.

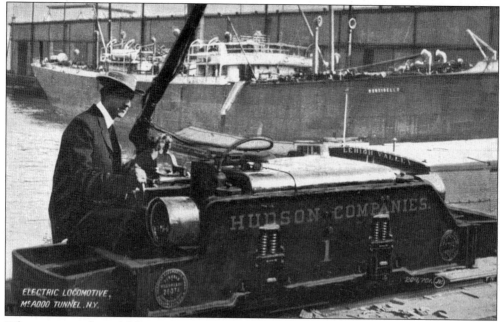

What appears to be a child's toy was an important component in the construction of the Hudson Tubes. This little electric locomotive could haul the carts filled with debris without polluting the atmosphere in the tunnel with smoke and coal fumes.

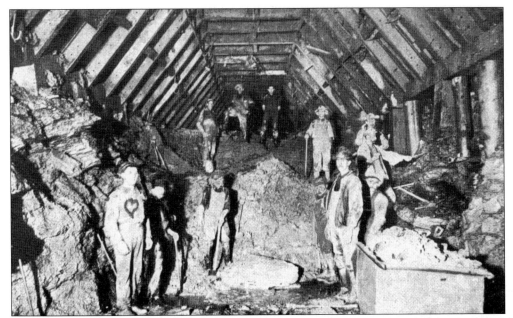

As Manhattan's subway system was being dug, sandhogs employed by the Hudson and Manhattan Railroad were burrowing beneath the Hudson River. The message on this card, dated May 10, 1910, reads, "The fellow with the heart on his shirt is my intended. Don't tell anybody! Love from Olga."

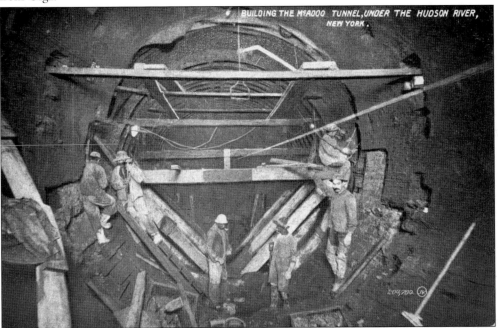

BUILDING THE McADOO TUNNEL, UNDER THE HUDSON RIVER, NEW YORK.

An action scene beneath the river captures the ongoing construction. The series of concentric cast-iron rings that form the foundation of the tunnel can be seen behind the work crew. Pneumatic devices known as Greathead shields maintained air pressure as the tunnel was being dug. These were named after the British engineer Sir James Henry Greathead, who developed the device in the digging of the Tower subway in London in 1880.

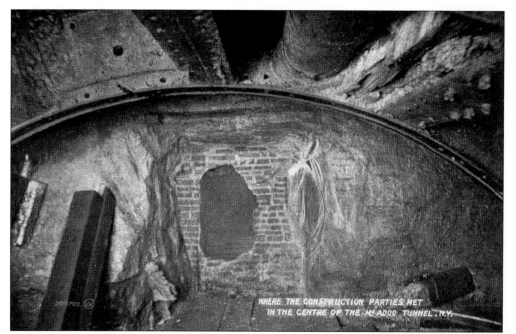

This view shows the site of the holing through, the meeting of the construction teams from both sides of the river. This joining occurred on March 11, 1904, about a month after the completion of the IRT.

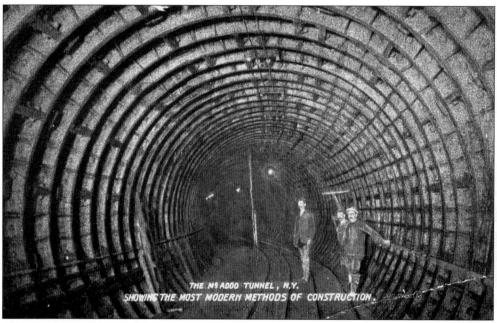

The completed section of the tunnel is pictured with the cast-iron rings in place. The tracks shown were laid to transport the carts used in the removal of debris.

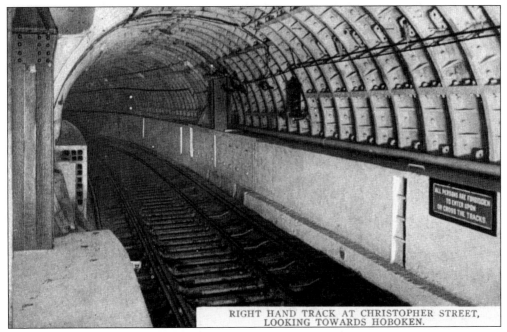

RIGHT HAND TRACK AT CHRISTOPHER STREET,
LOOKING TOWARDS HOBOKEN.

The iron rings lining the tunnel are seen from the Christopher Street platform. The sign reads, "ALL PERSONS ARE FORBIDDEN TO ENTER UPON OR CROSS THE TRACKS," an admonition only a fool would ignore.

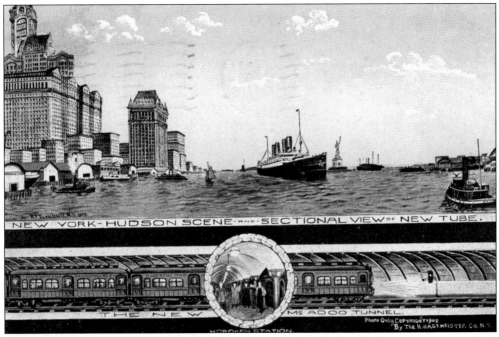

NEW YORK-HUDSON SCENE-AND-SECTIONAL VIEW OF NEW TUBE.

THE NEW McADOO TUNNEL.

HOBOKEN STATION.

Photo Only COPYRIGHT 1909
By The H. HAGEMEISTER Co. N.Y.

Downtown skyscrapers are massed to the left, with the 47-story Singer Tower and Building (1908–1970) dominating the skyline. The second set of Hudson Tubes, connecting New Jersey with lower Manhattan, is shown spanning the riverbed.

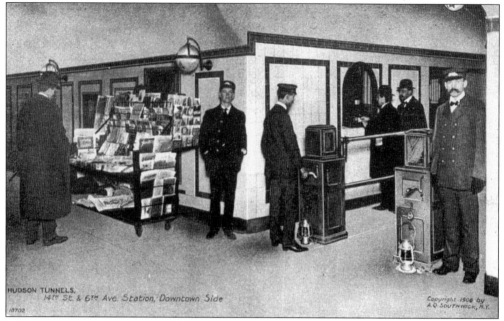

The entrance to the platform of the 14th Street Hudson Tubes station is shown on this card. Riders are buying their tickets at the booth. Platform men stand ready to accept the paper tickets and shred them in the mechanisms at the entrance to the platform. The moveable newspaper rack on casters displays dozens of papers and magazines to while away the time of the passengers in transit.

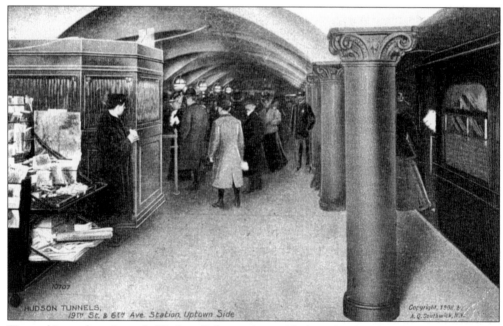

Pictured is another view of a Hudson Tubes station, with the ticket booth right on the platform. Again we see the ubiquitous newsstand. Passengers have just alighted from the train and are squeezing through the exit gate. The correspondent writes ruefully on the back of this postcard, "Bin [*sic*] through this many a time."

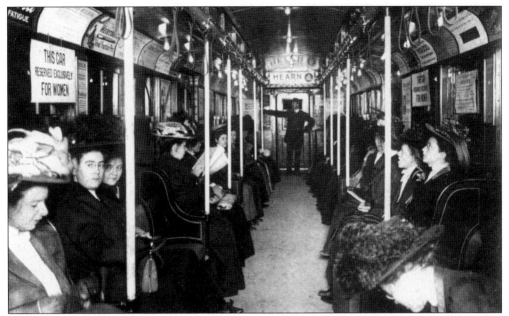

For a short period of time *c.* 1910, the Hudson Tubes offered at least one car on a train for the use of women exclusively. The only difference in accommodation was the sign reading, "THIS CAR RESERVED EXCLUSIVELY FOR WOMEN." Car cards above the longitudinal seats advertised the same products. The straps were still suspended from the ceiling, and the poles still afforded additional support for the standees. (From *Life in Old New York Photo Postcards,* by Dover Publications.)

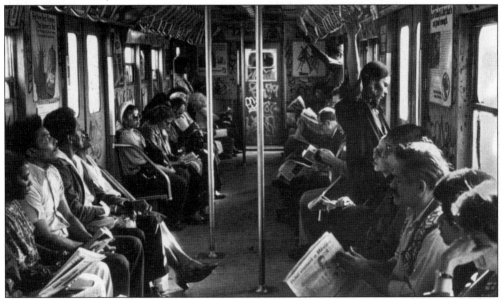

An interior view of a typical subway car of the 1980s shows only cosmetic changes over 70 years. The seats are made of formed plastic rather than rattan. The advertising car cards tout different products, the straps have been replaced by aluminum handles, and the riders are a mix of gender and ethnic backgrounds. Their daily routine, however, remains the same, getting from home to work and back again in reasonable comfort and at reasonable cost.

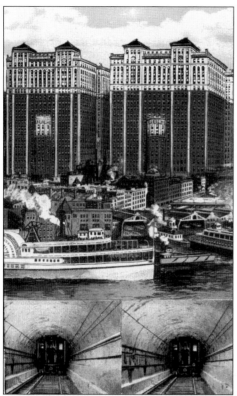

To quote the text on the reverse of this card, "the Hudson Terminal Buildings on Church Street, between Cortlandt and Fulton Streets, are twin structures and together form the largest office building in the world. It is 22 stories 375 feet high and has office room for 20,000 people. The Railroad Station is in the basement where twin tubes enter from Jersey City." The two buildings, straddling Dey Street, were demolished in the 1960s, to be replaced by the twin towers of the World Trade Center.

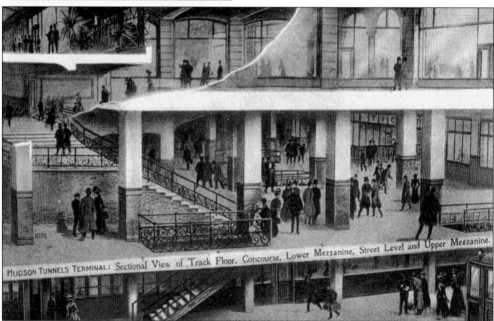

An elegant concourse and mezzanine were constructed over the tracks at the terminus of the Hudson Tubes in lower Manhattan. Much of the existing framework was useable in the 1960s modernization of the Hudson Tubes (now known as the Port Authority Trans-Hudson Corporation, or PATH) as part of the development of the World Trade Center complex.

Five
ART AND ARCHITECTURE

New York City's mass-transit system has drawn the interest of artists, photographers, and motion picture producers since the days of the Harvey elevated railroad of 1867. In this chapter is displayed a selection of artwork from the idealized portrayals of the subways and els to their nitty-gritty graffiti-laden stations and rolling stock. The artistic and architectural genius of the Heins & La Farge company is manifested in depictions of its murals and station designations, as well as its delicate sidewalk kiosks. Whether it is the artistry of John Sloan, the photography of Berenice Abbott, or the graffiti identified only by the artists' tags, it is all a part of the big picture.

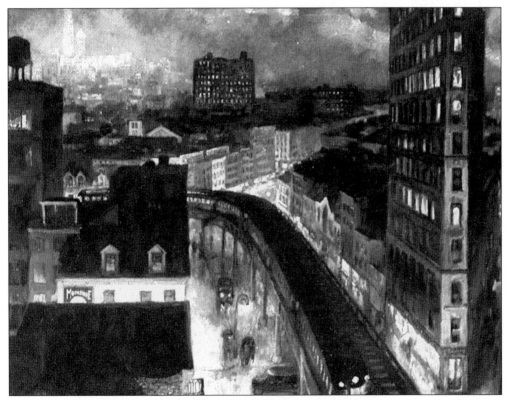

An el train negotiating a curve in Greenwich Village is captured by the artist John Sloan, an eminent member of the Ashcan School, in this 1922 painting entitled *The City from Greenwich Village*. (From *Six John Sloan New York Paintings Cards*, by Dover Publications.)

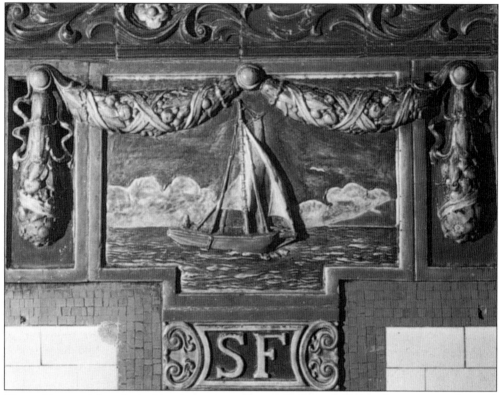

The architectural firm formed by the partners George Heins and Christopher La Farge designed not only the kiosk entrances to the subway but also much of the artwork of the stations. A series of decorative tiles adorned the platforms of the major stations, blending symbolism with city history. Shown in this design is a Hudson River sloop. The plaque is situated at the South Ferry station, the station nearest to the Hudson River.

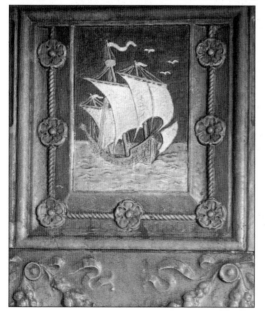

Carrying through on the nautical theme is this decoration at the Columbus Circle station at West 59th Street and Eighth Avenue. The ship quite naturally represents one of Christopher Columbus's caravels.

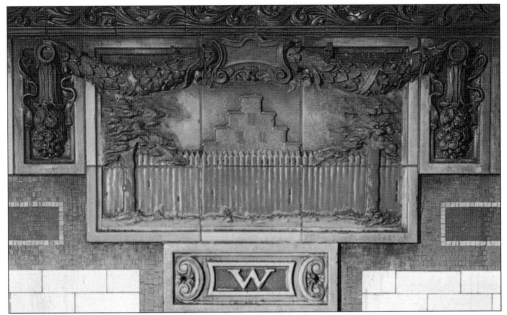

This subway mural is steeped in historical significance. The stockaded barrier represents the wall erected in 1653 by Peter Stuyvesant, the governor of the Dutch colony of New Amsterdam, to protect the citizens from invading English. A stepped gabled dwelling rises behind the protective wall. The W designates the name of the station—Wall Street.

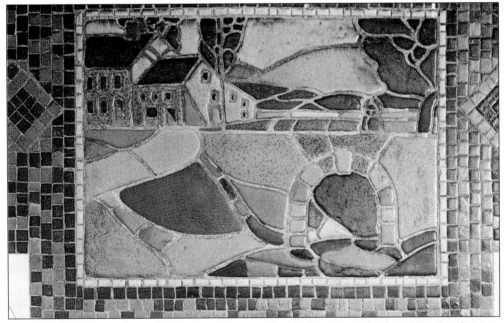

While the historic message of this mural is more obtuse, the name of the station, Canal Street, gives a clue. A canal was dug across Manhattan to drain what was named Collect Pond. The bridge spanned the canal. As Broadway was laid out going uptown, the bridge was absorbed into the roadbed.

71

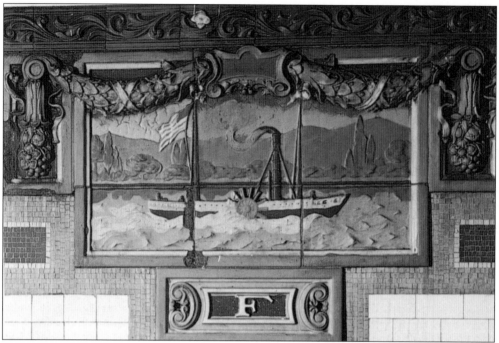

Another link to the city's maritime history was chosen for this decoration. It shows Robert Fulton's steamboat on the Hudson River. The boat was constructed in New York and was ultimately named *Clermont*, after the name of the estate of Robert R. Livingston, the chancellor of New York State and the inventor's financial backer and partner. The tiles graced the Fulton Street station.

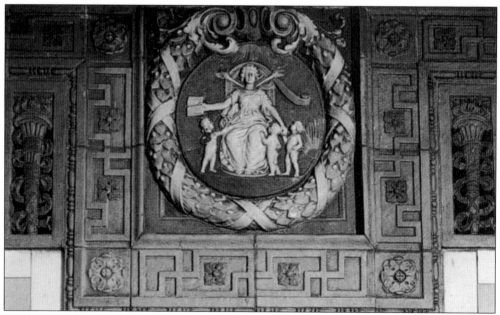

To decorate the Columbia University station of the IRT at West 116th Street, a seated female figure is shown imparting knowledge to surrounding children. The figure duplicates the seal of the university.

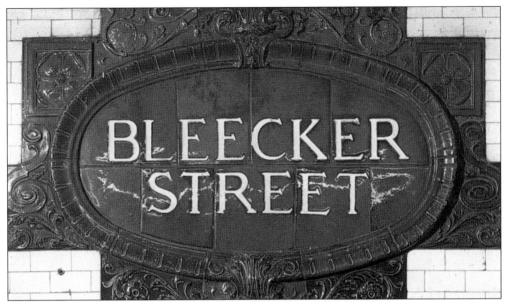

Glazed ceramic tile was used as station designations, or name tablets, throughout the three subway systems. The earlier lines featured these more flamboyant signs. This one could be seen at the Bleecker Street stop on the IRT line. The street was named for Anthony Bleecker, an early-19th-century poet whose family deeded part of its farmland for the road.

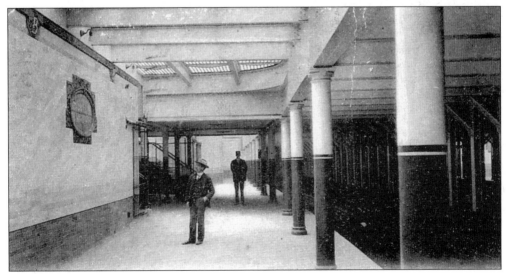

A passenger admires the vivid blue Bleecker Street station designation as it appears mounted on the white-tiled platform walls.

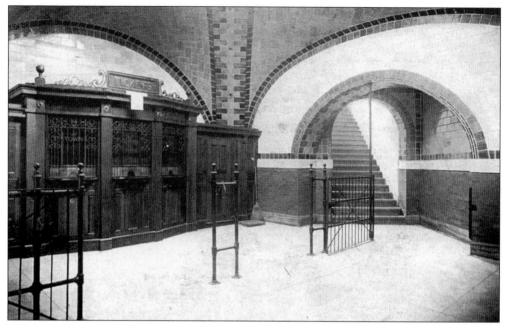

The New York City Hall station was the showpiece of the subway system. Employees in the ornate wooden ticket booths would dispense paper tickets for the 5¢ fare. When the system was in operation, the rider would surrender his ticket to another employee stationed in the gateway entrances and proceed to the track platform.

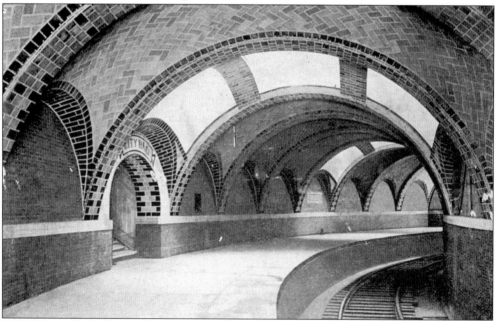

No electrification is evident in this view taken prior to the opening of the IRT line. The source of illumination was the sunlight filtering though the vault lighting in the ceilings. The wall and ceiling decorations are the product of Rafael Guastavino, an architect who emigrated from Barcelona, Spain, in 1881 and settled in Ashville, North Carolina. He used layers of thin tile embedded in layers of mortar.

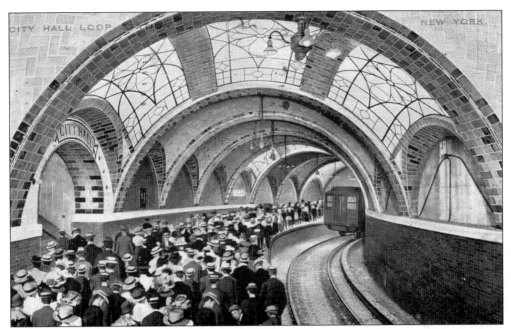

Rush-hour crowds line the platform, waiting to board the approaching train. The station was lighted by daylight coming through vault lights, by glass blocks embedded in the overhead sidewalks, and by incandescent bulbs in chandeliers over the tracks. Note the protected third rail, the source of power for the fully electrified subway system.

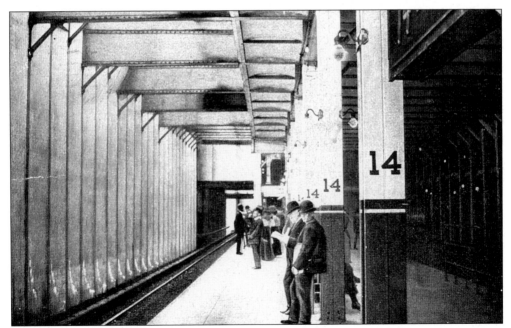

Contrast the purely functional architecture of this platform at East 14th Street. The platform has no artistic tiles and no allegorical plaques—just a place to wait a few minutes for the next train to pull in.

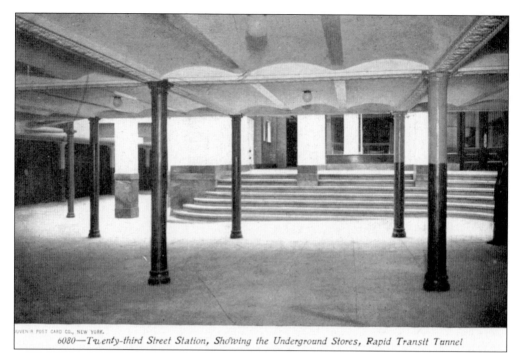

6080—Twenty-third Street Station, Showing the Underground Stores, Rapid Transit Tunnel

Judging by the pristine condition of the platform and stairs, these two views appear to be publicity photographs used to solicit tenants for the "underground stores" mentioned in the caption. Savvy merchants would have grabbed up this retail space to capitalize on the traffic generated by the thousands of riders using this busy 23rd Street IRT station each day.

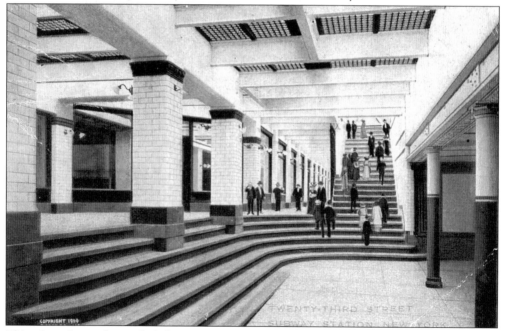

This view shows the vault lighting in prominence, illuminating the area near the staircase. The passengers on the steps have obviously been drawn in, since they are not in scale with the architecture.

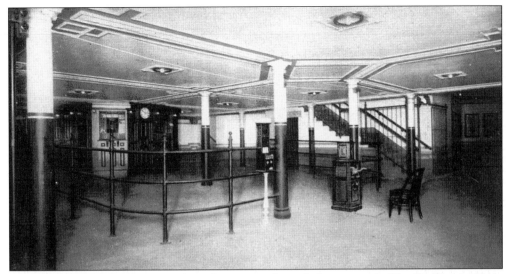

An operating subway station stands ready to serve the rush-hour crowds. The boxlike device in the center of this view is a ticket chopper. The chair would be occupied by the employee responsible for destroying each of the paper tickets. He would collect a ticket from the passing rider and, by firmly depressing the chopper handle, cut the ticket in two. The device on its pedestal to the left of the entranceway appears to be an early coin-in-the-slot vending machine selling confections.

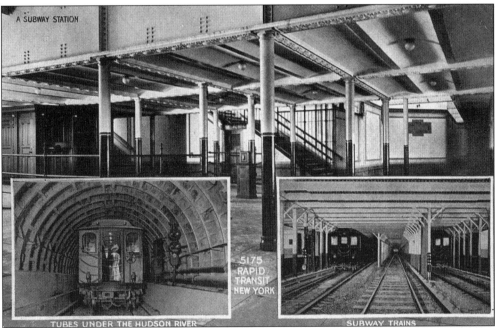

Little can be added to the legend on the reverse of this image. It reads, "The Subways of New York relieve much of the congestion formerly traveling over the Brooklyn Bridge. The Hudson Tubes are constructed through the heart of the business district, cutting under large buildings. They are four tracks wide, affording a local and express service. The Hudson Tubes, operated from 34th and Broadway under the Hudson River in New Jersey points, reach as far as Newark."

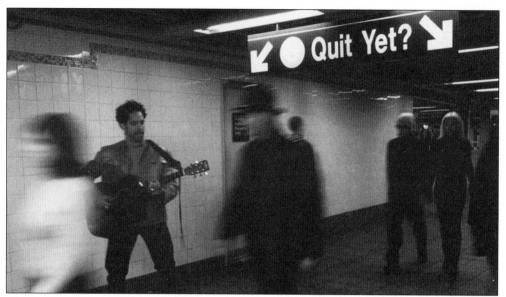

A designer used an ordinary view of a modern subway platform to publicize the Quit Yet? antismoking campaign of the New York City Department of Health. The overhead signage has been altered. The circle would usually designate the line running on the track (the A, E, 2, or 3 lines). The wording would typically indicate the destination of the train, such as "To Coney Island." The platform performer is a common manifestation of city life, with his guitar case open to accept the donations of the riders passing by.

As individual stations are refurbished, the familiar white glazed tiles are being replaced by other materials. Shown here is a subway entrance faced with brick. The riders descending the stairs underline the ethnic diversity of modern New York.

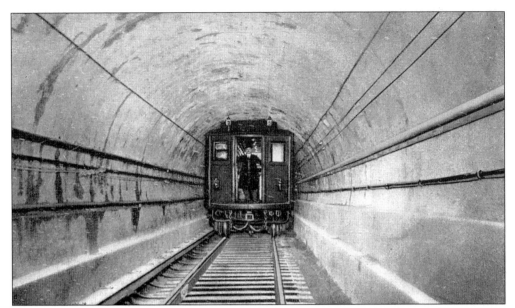

A Lo-V train traverses the tunnel under the East River, linking Manhattan and Brooklyn. The third rail power source is to the left of the tracks. Catwalks on the side of the tunnel are available to evacuate passengers in case of a power outage. A train crewman is silhouetted in the open storm door.

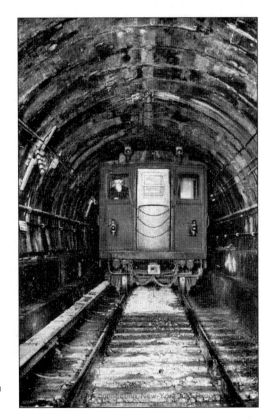

In this view of the tunnel, the motorman is situated in his control cab. The window to the right was often used by passengers of all ages to experience the thrill of riding through the tunnel.

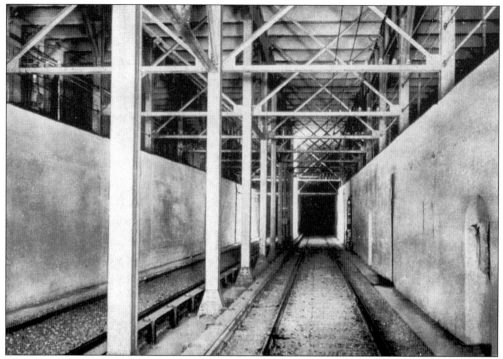

The subway right of way at West 98th Street is shown here, crisscrossed by girders supporting another line and the street above. The declivities in the side walls are called manholes, shelters in which track crews waited until an oncoming train passed by their work site.

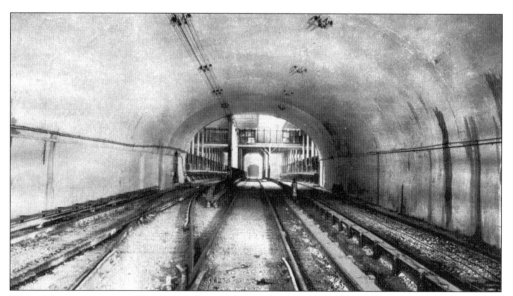

The widened tunnel at West 117th Street allows for switching of local trains running on tracks along the walls of the tunnel to the centralized express tracks. It is common to ride trains that are "locals" for a portion of the ride and then an "express" for the balance.

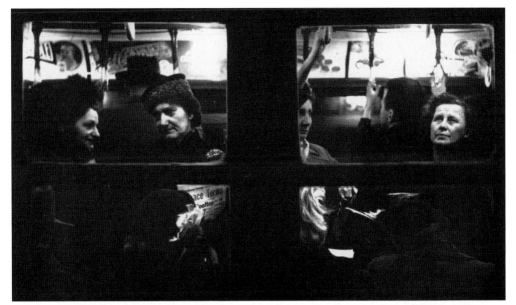

This group of subway straphangers appears to be made up of women on their way to an afternoon of shopping. Although the photograph by Sy Kettelson was taken in 1949, the view, with only cosmetic change in garb and interior detail, could be from any period over the last 90 years.

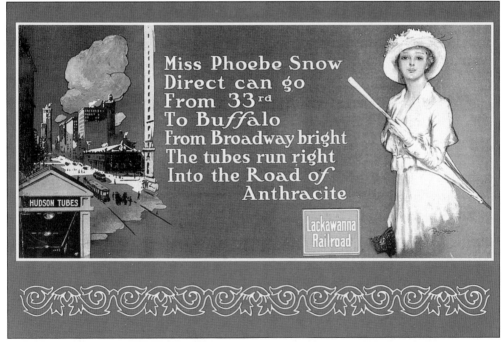

Phoebe Snow was a mythical character thought up during an advertising campaign of the Lackawanna Railroad. This view shows the prim Miss Snow praising the direct rail link via the Hudson Tubes at Herald Square to Buffalo. What is not mentioned is the necessary change of trains on the New Jersey side, from the Hudson Tubes to a Buffalo-bound railroad train.

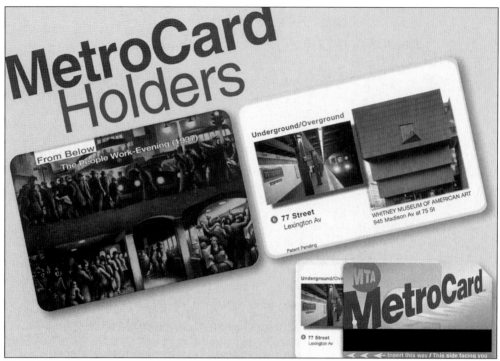

New York City's Metropolitan Transportation Authority (MTA) chose postcards to advertise the use of its Metrocard, a system of prepaying for a number of rides and recording the information electronically on a pass card. A swipe at the turnstile gets you to the train and deducts one fare on the card. The need to purchase individual tokens is thus eliminated.

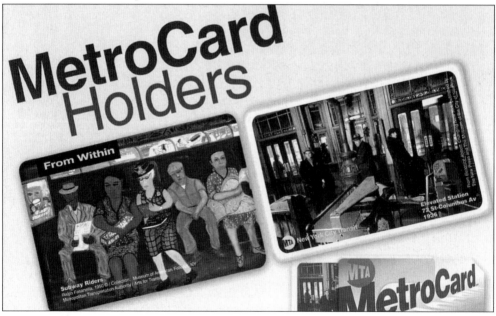

Berenice Abbott's 1936 photograph of the interior of the el station at West 72nd Street and Columbus Avenue was chosen as the subject for this advertisement. The painting reproduced to the left is entitled *Subway Riders,* by Ralph Fasanella.

The Metropolitan Transportation Authority displayed creativity in choosing these two views of lower Manhattan. To the left is the town of New Amsterdam, the Dutch-style houses clustered around the fort. The tall structures are a windmill (left) and, within the fort's walls, the Dutch Reformed Church (right). The vignette to the right is a modern view of the tip of Manhattan.

To the right on this card appears *Tunneling Through,* depicting the extension of the East 63rd Street line under Roosevelt Island, thereby opening access to the island, situated in the East River, from Manhattan and Queens.

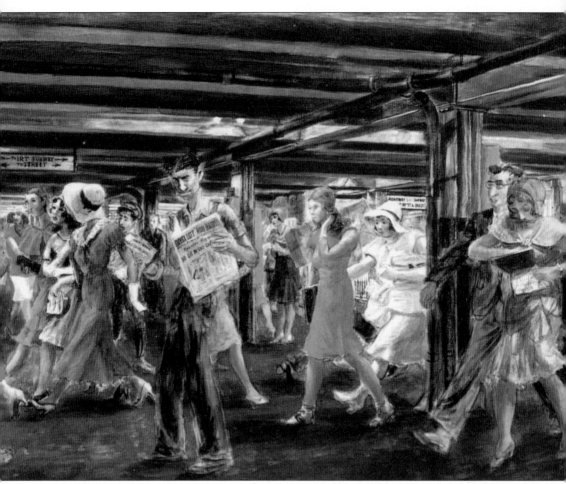

Artist Reginald Marsh's 1930 view of a typical rush-hour scene shows the determined stride of the office workers passing an idler perusing his newspaper as he waits for the next train. In a survey of subway foot traffic undertaken as part of the construction of the transportation complex at the World Trade Center, New Yorkers were clocked as walking 30 percent faster than the rest of the country—if not the world.

A favored shop in Greenwich Village serves as a focal point to contrast the modifications of subway entrances over the years. While the entrance to the left of the building remains substantially the same, note the differences in detail. The globe in this view is cube shaped, similar to those that for years designated the IND line. The sign indicates that the station served the IRT line. (Photograph by Seth Allen.)

A current view of the same corner shows the more familiar colored globe atop the stanchion marking the stairs. The signage indicates the station's designation as Christopher Street and that it serves the 1 and 9 trains going downtown. (Photograph by Gail Greig.)

The Colgate company capitalized on the image recognition of the el by choosing this view to advertise its brand of soap. The image appeared in the September 7, 1878 issue of *Harper's Weekly* and shows the elevated at Franklin Square near the New York City Hall area. This is a Dover Publications reproduction of a trade card from the New-York Historical Society collection.

The 1922 silent movie *The Frozen North,* starring comedian Buster Keaton, used a model kiosk as a prop. Such was the nationwide recognition of this common New York City street structure.

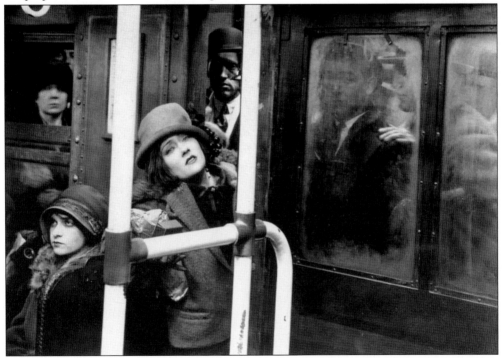

Film star Gloria Swanson manages to squeeze herself onto a subway train in the 1924 silent movie *Manhandled.* Scenes on the New York subways and els often appear in motion pictures. Virtually the entire action takes place aboard subway cars in the movie *The Taking of the Pelham One Two Three,* the story of a hijacking of a subway train, with its passengers being held as hostages.

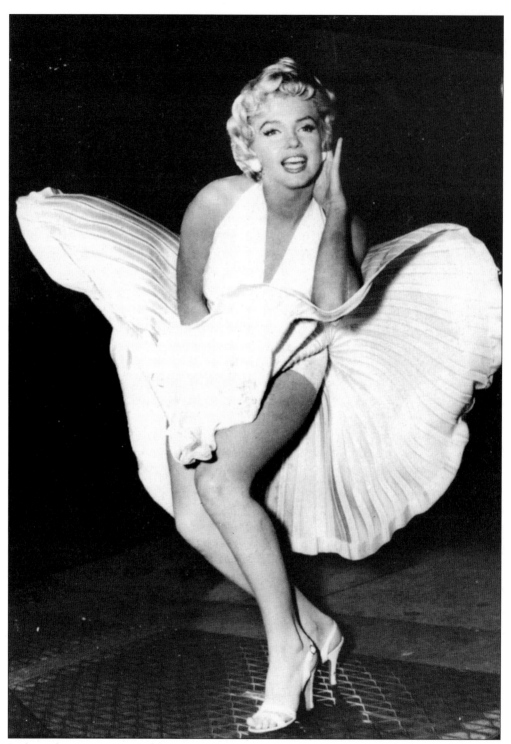

Perhaps the most recognizable scene in motion pictures is this one—Marilyn Monroe's skirt being blown up by a gust of air from a subway grate. The movie *The Seven Year Itch* premiered in 1955. (Photograph by Marty Zimmerman.)

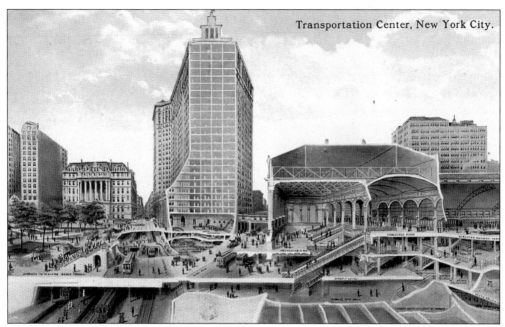

A greatly romanticized cutaway view of the transportation center at the foot of the Brooklyn Bridge is shown on this 1913 view. A contemporary description rhapsodizes "the most wonderful and complete transportation terminal in existence. Three radiating surface car systems, two subways and two elevated systems operated without conflict or congestion, and without interference with entrance to Brooklyn Bridge promenades and driveways." This is not a bad deal for a 5¢ fare.

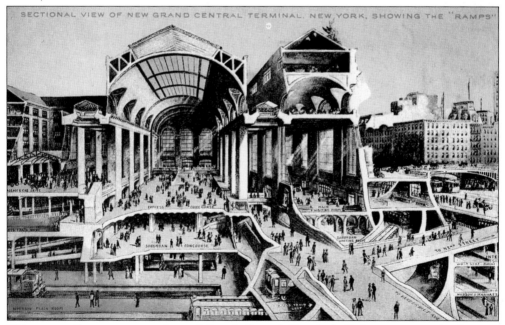

This extraordinary cutaway view of Grand Central Terminal discloses, way at the bottom, linkages from the railroads to the city's rapid-transit system. There is not a busier transportation hub in New York.

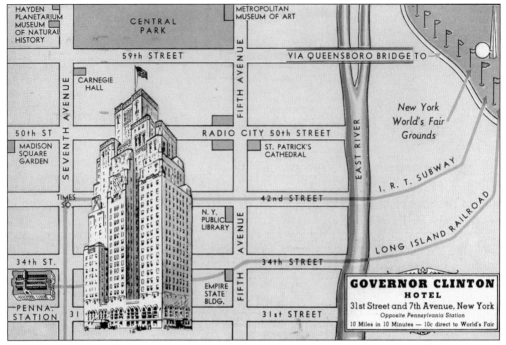

The graphic artists often used subway routes in their designs to entice customers. This view, with its reference to the IRT subway connecting to the site of the World's Fair, dates it as being produced in 1939–1940. Note the "10 Miles in 10 Minutes—10¢ direct to World's Fair" legend, the fare being double the usual amount to pay for this service, which lasted until the fair's closing.

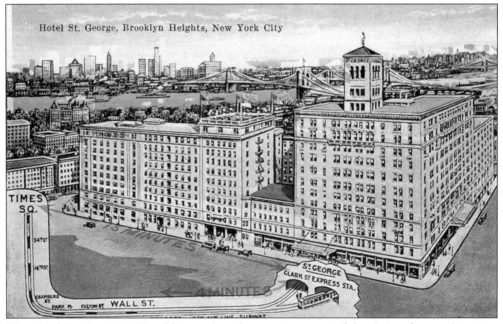

The Hotel St. George in Brooklyn used a subway map as part of the design for an advertising card. It announces a 4-minute running time to Wall Street and 15 minutes to Times Square from the Clark Street express station in Brooklyn.

90

Six

CHANGING CITYSCAPES

The construction and ultimate dismantlement of the elevated lines in Manhattan engendered a profound impact on the city's streets. Pleasant byways were once shrouded in perpetual shadow as the overhead el tracks blocked the sunlight. The kiosks of the subway that ultimately replaced the els, for all their grace, disrupted sidewalk traffic and blocked the view of the drivers of the cabs, buses, trucks, and private automobiles that had dominated street traffic by the 1930s. In the more than 100 years of the existence of picture postcards, their images have documented the change in the cityscape.

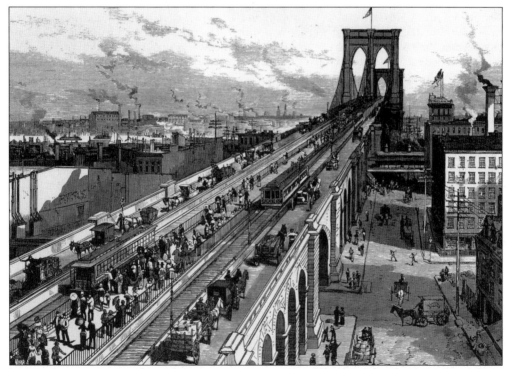

The opening of the Brooklyn Bridge in 1883 represented the first direct link of vehicular and pedestrian traffic between Brooklyn and Manhattan. Provisions for cable cars, on eastbound and westbound tracks, were perceived as a necessity to bring the Brooklyn residents to their jobs in the burgeoning business and financial districts in Manhattan. (From *A Picture History of the Brooklyn Bridge,* by Dover Publications.)

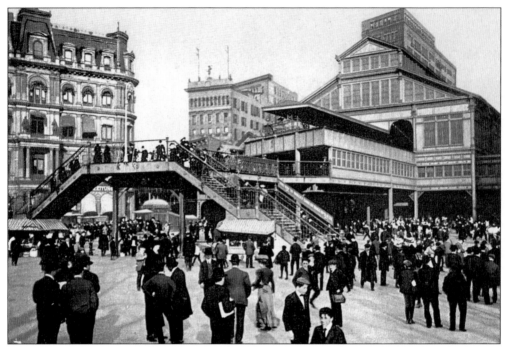

The most intrusive structure associated with the elevated railroad system was this graceless terminal at the Manhattan end of the Brooklyn Bridge. Hoards of humanity would stream out of this shed and then disburse to the el, subway, and surface lines around New York City Hall. The building to the left is the plant for the German-language newspaper *Staats Zeitung,* constructed in 1870. The building with the flagpoles is the 1872 Newsboys Lodging House.

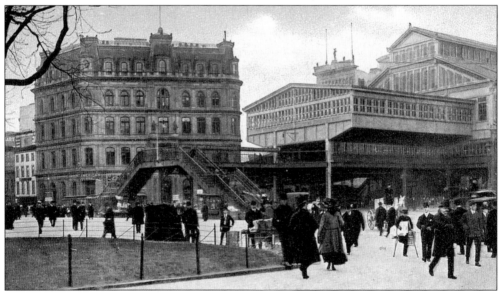

A few years after the previous photograph was taken, some cosmetic improvements were made to the shed, not for aesthetic purposes but to shelter the emerging commuters from the elements. This defacement to the New York City Hall area remained until the 1940s, when surface transit cars were removed from the Brooklyn Bridge.

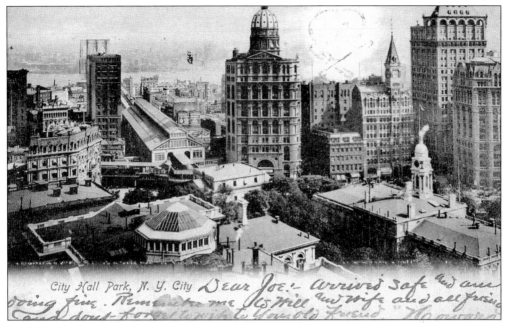

City Hall Park, N. Y. City *Dear Joe:- Arrived safe and are doing fine. Remember me to Will and wife and all friends and I don't forget to write. Your old friend "Howard"*

This aerial view portrays the clutter caused by the shed at the foot of the Brooklyn Bridge. The domed building in the foreground is the Tweed Courthouse (1878). The back of the cupola-topped New York City Hall is shown to the right. Along what was called Newspaper Row are, from left to right, the domed World (or Pulitzer) Building, the Herald Building, the American Tract Society Building, and the New York Times Building.

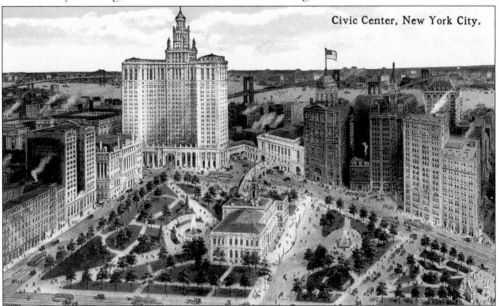

Civic Center, New York City.

As early as 1913, the aesthetes among the New Yorkers envisioned this fanciful view of a civic center surrounding New York City Hall. Gone were the Tweed Courthouse and the post office building. To quote the text on the back of the postcard, the concept included the substitution of "the present unsightly sheet iron shed at the Manhattan end of the Brooklyn Bridge by an ornamental terminal arranged to abolish the 'crush' of the rush hour."

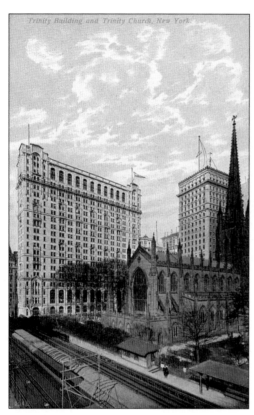

Trinity Place, to the west of the grounds of Trinity Church (1846), was the route of the el going up the west side of Manhattan. The station and elevated right of way mars this view looking northeast.

The destruction of the el opened up the Trinity churchyard to the sunlight. A stairway entrance on the sidewalk leads to the subway line that succeeded the el. The largest of the buildings in the background is 120 Broadway, originally named the Equitable Building (1915). Zoning regulations were changed in 1916 because of the bulk of this building.

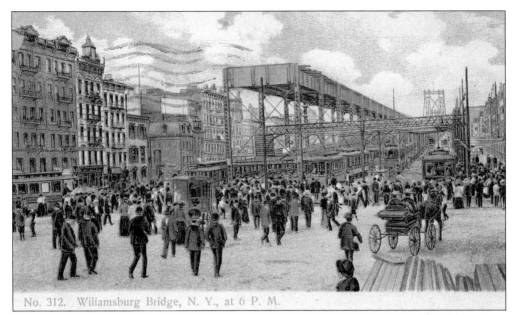

No. 312. Wiliamsburg Bridge, N. Y., at 6 P. M.

The Williamsburg Bridge, upon its completion in 1903, became as cluttered with surface traffic as the Brooklyn Bridge was to its south. Dozens of surface streetcars can be seen ready to receive Brooklyn-bound office workers on their way home.

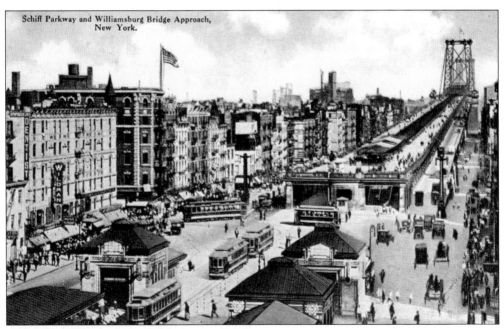

Schiff Parkway and Williamsburg Bridge Approach, New York.

This view, taken perhaps 10 years later, shows the bridge approach "prettified" but still an impediment to vehicular and pedestrian traffic on the city streets. The broad thoroughfare leading to the bridge is the Schiff Parkway (a widened Delancy Street), named after the philanthropist Jacob Schiff. The squat structures with the pyramidal roofs were entrances to the subway.

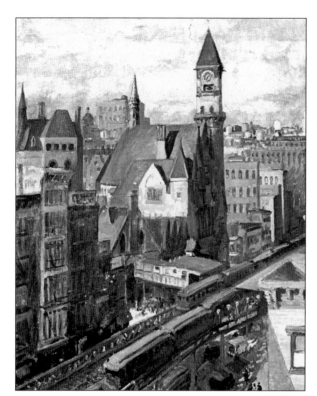

John Sloan, noted artist of the Ashcan School, painted this scene of the Jefferson Market Courthouse, with the el right of way passing beneath its tower on Sixth Avenue at West 10th Street. The painting is among the holdings of the Pennsylvania Academy of Fine Arts.

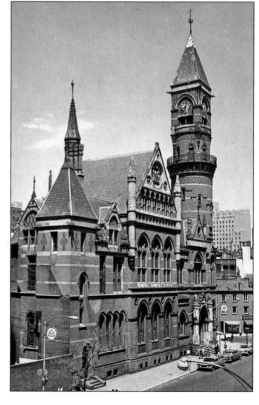

This photograph shows the courthouse building, with Sixth Avenue open to the sunlight. The building, constructed between 1874 and 1877, now stands alone, serving as a library building. Its adjoining prison was razed in 1927. The medallions on the lampposts bear the coats of arms of Latin American countries.

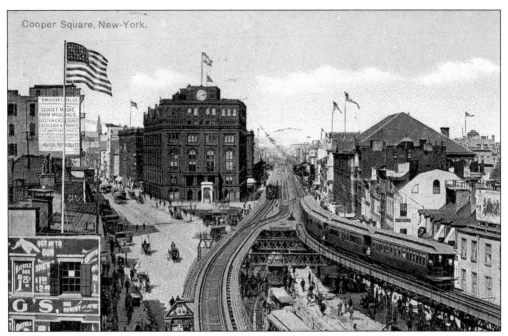

The view on this card, postmarked 1909, looks up from the foot of Third Avenue as the street absorbs the traffic from the Bowery, which terminates at East 4th Street. To the left is Cooper Union. The building to the right of the tracks was the armory of the 7th Regiment.

This modern view, looking north on Third Avenue, shows Cooper Union dwarfed by the towers of the Empire State Building at 34th Street, the Consolidated Edison Building at 14th Street, and the Chrysler Building at 42nd Street. The round structure on the roof of Cooper Union is an elevator shaft. Industrialist Peter Cooper designed a round elevator in the original plans for the building.

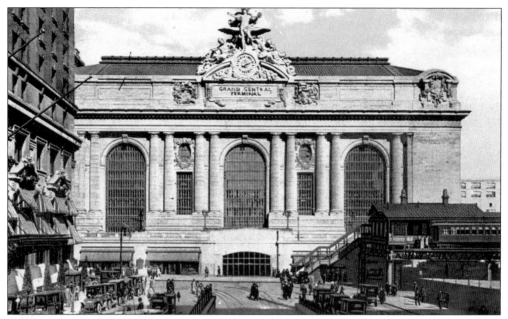

This view shows the recently completed (1913) current Grand Central Terminal, with the station of the East 42nd Street spur line prominent at Park Avenue. Although it was still an eyesore to the cityscape, the spur served the useful purpose of connecting the railroad terminal to the city's Third Avenue elevated line.

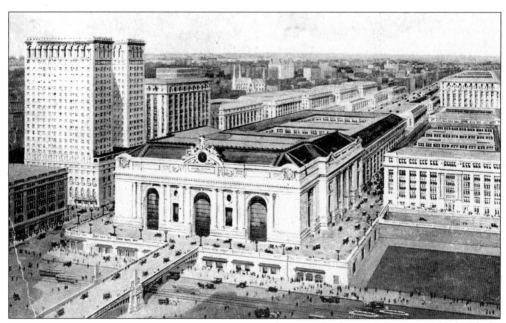

This fanciful view of Grand Central shows the 1917 ramp bringing vehicular traffic around the building and the absence of the spur line. The neat phalanx of white-marble classical buildings lining both sides of Park Avenue north of the terminal is wishful fantasy.

In this view looking west toward the Empire State Building at Fifth Avenue, East 34th Street is shaded by the el track on even the sunniest days. This east–west branch connected the Third Avenue el to the ferry slips on the East River. The automobiles at the curb date the view to the 1930s.

Note the transformation of this important crosstown street with the elimination of the el. The Empire State Building seems to soar higher. Even the tower of the 71st Regiment Armory at Park Avenue seems to be taking a breath of fresh air. This card is postmarked 1954.

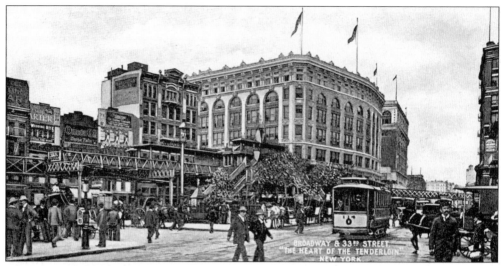

In this view looking uptown from West 32nd Street, the el tracks and station predominate. The substantial building with the two flagpoles housed the Saks 34th Street department store (1902) on the southwest corner. On the northwest corner was, and still is, Macy's (1902).

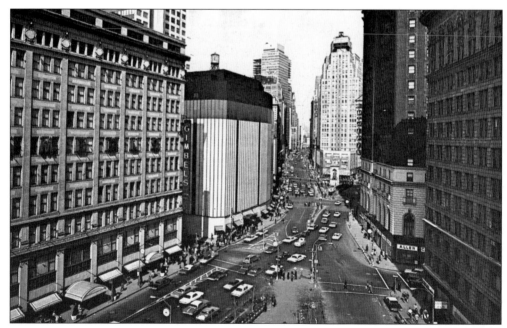

The department stores on West 34th Street were joined in 1912 by Gimbel's, which occupied the site between West 32nd and 33rd Streets. In this view, the Saks building has been given a facelift by its new occupant, E.J. Korvette's. The el has been torn down, opening up the street. Subway lines and PATH now serve the Herald Square area.

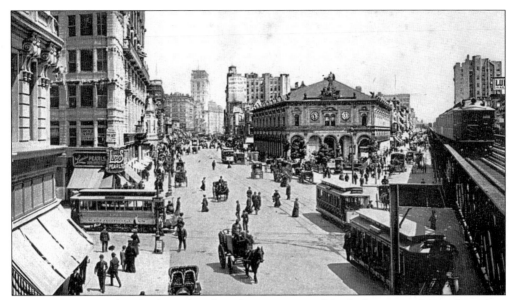

West 34th Street splits the hourglass-shaped intersection of Sixth Avenue and Broadway into Greeley Square to the south and Herald Square (pictured here), to the north of the cross street. Herald Square was named for the New York Herald newspaper, which occupied the central building (1893–1940), with the sculpture on its roofline. Looking up Broadway, this view shows the New York Times Building (left), at 42nd Street, under construction.

In this view from the 1930s, not only has the elevated been removed from Sixth Avenue but the Herald Building itself has disappeared from view. The statuary from the roofline—entitled *Minerva and the Bell Ringers* (erected in 1895), by sculptor Antonin Jean Carles—chimes the hours in the little park (Herald Square) that now occupies the newspaper building site.

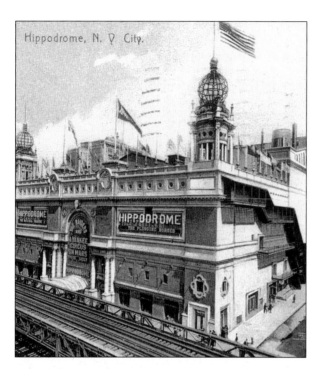

Hippodrome, N. Y. City.

The impressive Hippodrome Theater (1905), known for its extravaganzas, occupied the east side of Sixth Avenue between West 43rd and 44th Streets. Its pleasant front façade was hidden by the obtrusive tracks of the el.

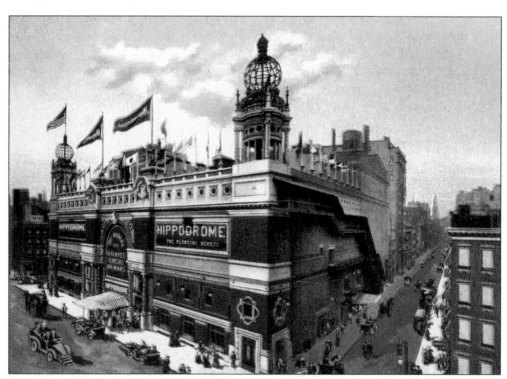

Long before the el's dismantlement in 1938, an enterprising artist painted out the tracks and drew in his rendition of an unencumbered view of the building's main entrance. The Hippodrome itself was razed for an office building within a decade.

The delightful Art Deco façade of the Radio City Music Hall at West 47th Street is obscured by the station and tracks of the Sixth Avenue el. The el discontinued operations in 1938, six years after the completion of the Rockefeller Center landmark.

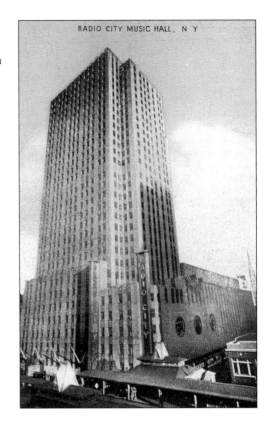

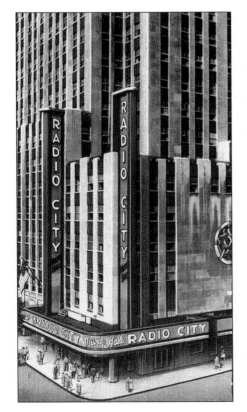

The theater's façade is fully exposed to the camera's eye in this linen-era view taken after the removal of the el. The iron and steel from the dismantled els was sold as scrap in the world markets. One purchaser was the empire of Japan. World War II veterans are convinced that the metal was returned to us, in a somewhat altered form, at Pearl Harbor, Guadalcanal, and Iwo Jima.

For 60 years, this graceful el station straddled West 42nd Street at Sixth Avenue. Bryant Park is to the left of this view looking west. The New York Times Building (1904), for which Times Square and the subway stations are named, punctuates the skyline.

Looking west, this 1960s view shows 42nd Street. The scene features no elevated station, but there is street traffic galore. The Times Tower is the building farthest to the right.

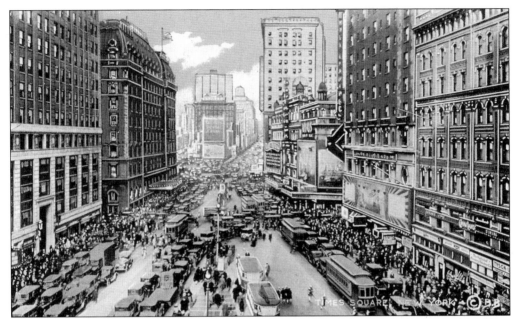

Although Times Square avoided the defacement of elevated tracks, streets at this intersection of Seventh Avenue and Broadway north from West 42nd Street, bore the brunt of heavy streetcar and automobile traffic. Major buildings to the left of the intersection are the Paramount Building (1926) and the Hotel Astor (1904–1967). To the right are the Olympia Theater (1895–1935) and the Hotel Claridge (1910–1972).

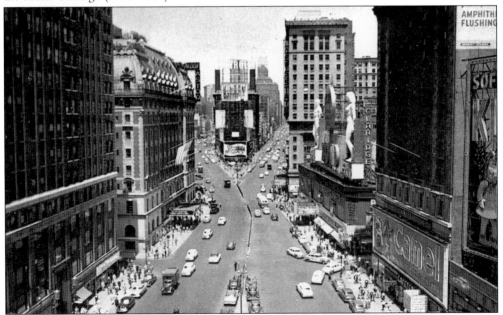

The increased use of the combined subways substantially eased the street traffic. A similar perspective from the 1950s shows the building at the left unchanged. To the right, a commercial building housing Bond's Clothes (with undraped male and female statues at its roofline) has replaced the theater. The famous Camel man, emitting his steam smoke rings, adorns the Claridge building. Little Lulu hawks Kleenex on the adjacent building.

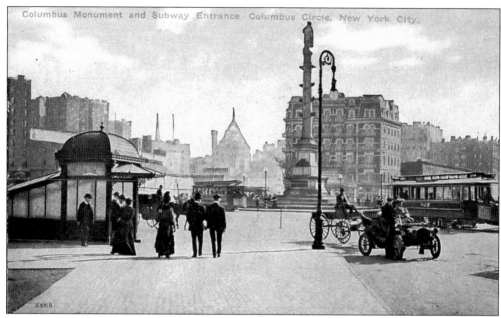

This view of the IRT subway entrance at Columbus Circle highlights a streetcar and early automobile, plus a stylish shepherd's crook lamppost. Digging the subway without damaging the 1892 monument to Columbus by sculptor Gaetano Russo was an engineering challenge.

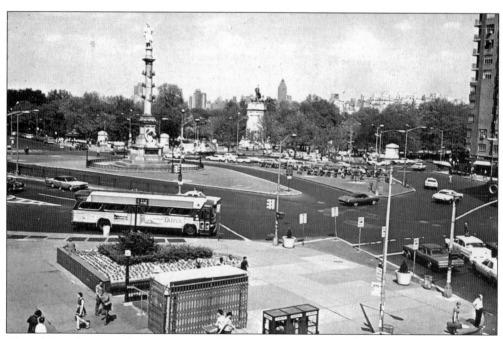

The white cubes atop the entrance stanchions mark the current subway entrance. Motorbuses and cabs abound on the street. A gated newsstand and telephone booths add to the street furniture in this 1960s view. Columbus still stands on his column.

Seven
TRANSPORTATION HUBS

Over the years, since the construction of the elevated lines in the 1870s, the goal has been to transport the greatest number of passengers to their destinations within the shortest period of time. Although surface transportation opened upper Manhattan and the outer boroughs to residential development, the twice-daily crush of both natives and visitors from upstate and New England required a series of sheltered transfer points within the city.

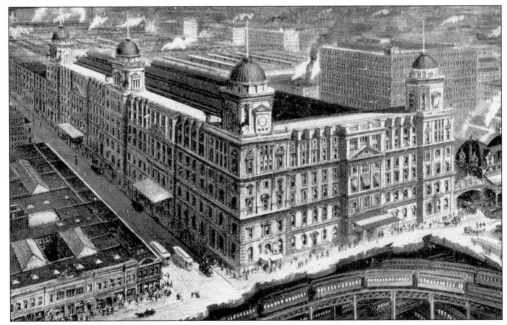

This artist's conception shows the IRT subway veering west toward Times Square. At street level to the extreme right is the terminal of the 42nd Street spur line of the Third Avenue elevated. Railroad commuters would take the subways and els to their intown destinations.

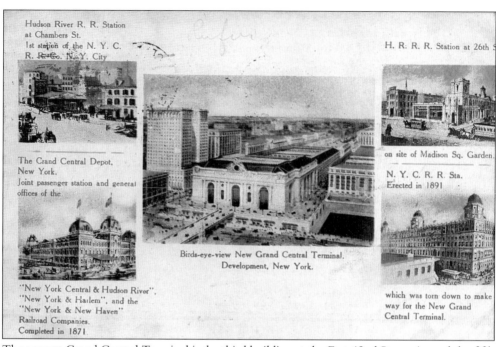

Hudson River R. R. Station at Chambers St. 1st station of the N. Y. C. R. R. Co. N. Y. City

The Grand Central Depot, New York. Joint passenger station and general offices of the

"New York Central & Hudson River", "New York & Harlem", and the "New York & New Haven" Railroad Companies. Completed in 1871.

Birds-eye-view New Grand Central Terminal. Development, New York.

H. R. R. R. Station at 26th St.

on site of Madison Sq. Garden.

N. Y. C. R. R. Sta. Erected in 1891

which was torn down to make way for the New Grand Central Terminal.

The present Grand Central Terminal is the third building at the East 42nd Street site and the fifth depot used by what began as the Hudson River Rail Road. As a result of fatal steam engine explosions in the more populated sections of the city, engines were banned below 42nd Street, thus setting the site for the terminal, completed in 1913.

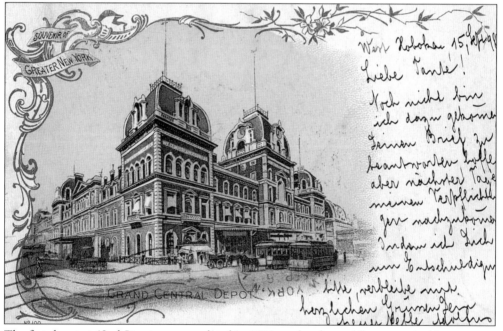

SOUVENIR OF GREATER NEW YORK

GRAND CENTRAL DEPOT

The first depot at 42nd Street was completed in 1871, as the elevated lines were inching uptown along Third Avenue. In this view looking east, the spur line terminal can be seen to the extreme right behind the streetcars.

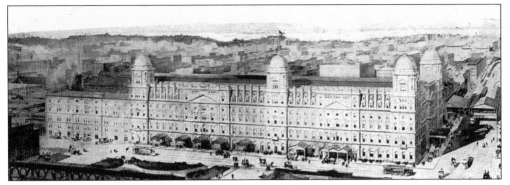

The second depot building at this site, completed in 1891, is shown in this view, again looking east. The spur line station straddling 42nd Street is quite evident.

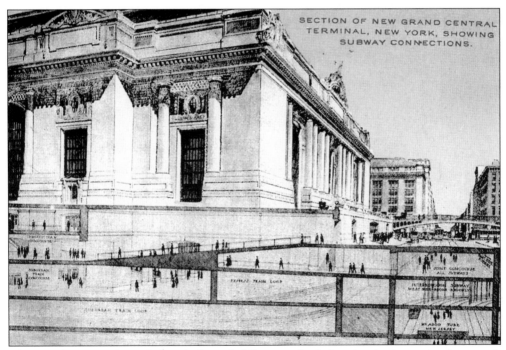

SECTION OF NEW GRAND CENTRAL TERMINAL, NEW YORK, SHOWING SUBWAY CONNECTIONS.

This artist's conception of Grand Central delineates the below-level access to other transit facilities from the main terminal building. The viaduct across 42nd Street was eventually constructed in 1917 to lift vehicular traffic above the street and around the terminal. The spur was demolished in 1923. The entire Third Avenue elevated line was torn down by 1955.

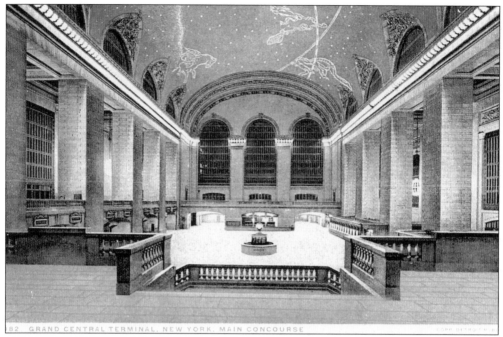

Commuters rushing through the terminal to make their connections deprive themselves of the magnificent vista of the main concourse of Grand Central. Its clean, classical columns are enhanced by the artists Whitney Warren, Paul Helleu, and Charles Basing's rendition of the signs of the zodiac on the ceiling. An entrance to the Lexington Avenue subway is through the archway on the right in this view looking east.

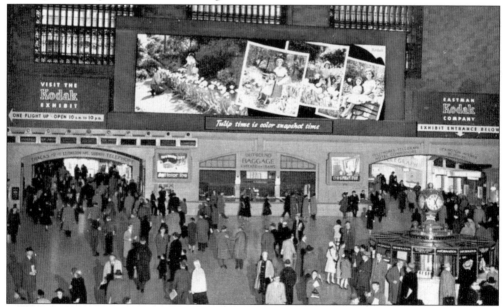

Crass commercialization defaces the eastern wall of the concourse in this close-up view. The signage was erected in 1950 and was mercifully taken down in 1990 in preparation for the major refurbishment of the entire complex. The archway to the left leads to the exit onto Lexington Avenue; the one to the right leads to the below-ground transportation hub.

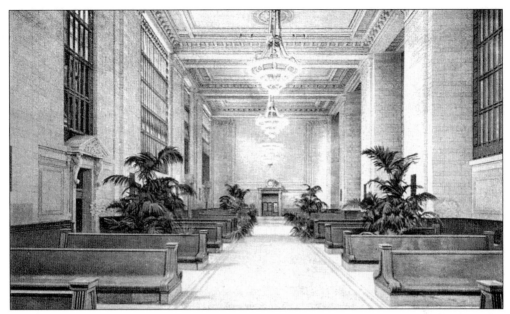

The elegance of Grand Central is manifested in its waiting rooms, where the long suffering straphanger could immerse himself in classic surroundings as he waited for his connecting train.

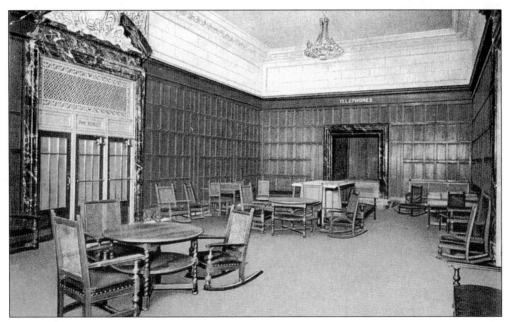

In the genteel age of the early 1900s, women were provided with their own waiting room. The room had a clublike atmosphere and featured rocking chairs, toilets (note the "pay" designation over the center door on the left), and an alcove containing public telephones.

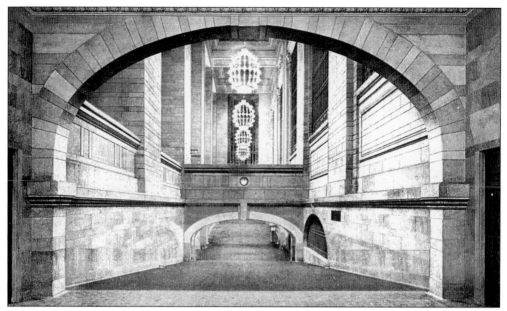

The incline connects the commuter railroad level to the subway level beneath the terminal. During the daily rush hours, the passage would be filled wall-to-wall with office workers starting or ending their days.

This view portrays the transportation hub below the spacious ground-level concourse. To the left is an information booth and timetable racks. To the right is a rank of railroad train ticket booths. Behind the square column, additional ramps to the subway give riders the choice of going south to lower Manhattan or west to Times Square.

A solitary kiosk at the foot of the majestic New York Times Building belies the below-surface activity as the IRT curves north under the building. Its basement is honeycombed by station platforms and track rights of way, all hidden away, leaving the streets unencumbered. The massive Hotel Astor is seen to the north.

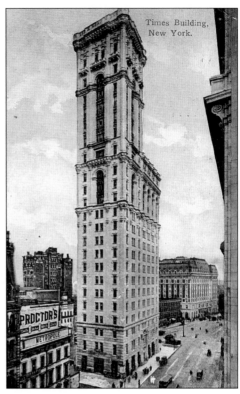

This view looks west along 42nd Street. The New York Times Building is seen on its little triangular island, bounded on its east by Broadway and west by Seventh Avenue. The Victoria Theater is seen across Seventh Avenue. The kiosk still stands guard over the subway beneath.

The New York Times Building casts its shadow over the subway entrance in this view looking east toward the corner of Broadway and West 43rd Street. Proximity to the subway and other forms of mass transit was, and still is, a major consideration in the location of commercial establishments, especially hotels and stores.

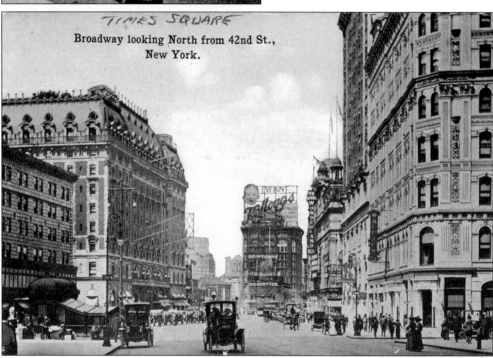

TIMES SQUARE

Broadway looking North from 42nd St.,
New York.

A street-level view of the kiosk includes examples of early automobiles facing south on Broadway. The building to the left of the subway entrance is the Putnam Building, so named because of a wartime meeting on this site in 1776 between Gen. George Washington and Gen. Israel Putnam. This building was replaced by the Paramount Building in 1926. Note the advertisement for Kellogg's cereal products mounted atop the Studebaker Building in the center.

As subway ridership increased in the Times Square area, more entrances were cut into the sidewalks. This view, taken from an upper story of the New York Times Building, shows the southeast corner of Broadway and West 42nd Street. Kiosks flank the intersection. A crosstown streetcar makes its way east on 42nd Street.

Hotel Knickerbocker, New-York City.

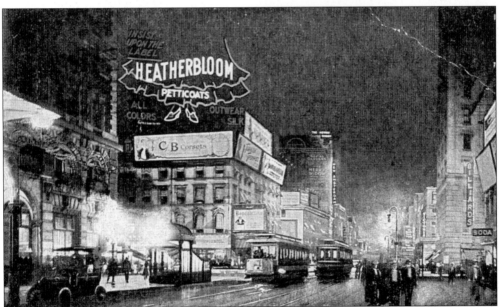

A street-level view looking west along 42nd Street features the subway entrance at Broadway. The animated advertisement for women's garments was one of the first such signs appearing in Times Square. These signs, with blinking lights and simulated moving figures, made a visit to Times Square an exhilarating visual experience.

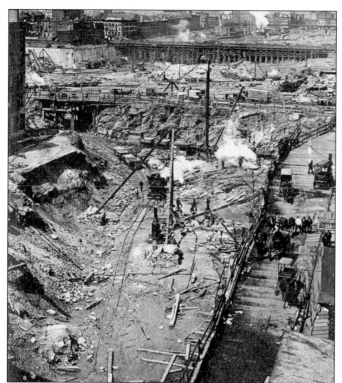

When the Pennsylvania Station at Seventh Avenue between West 31st to West 33rd Streets, extending to Eighth Avenue, was completed in 1910, the retail shopping area was served by the Hudson Tubes and the Sixth Avenue and Ninth Avenue elevateds. The Pennsylvania Railroad, tunneling beneath the Hudson River, opened up the 34th Street retail district (and office jobs) to New Jersey and Pennsylvania residents, as well as those from Long Island via the Long Island Railroad under the East River. Shown here is the excavation for this huge transportation hub.

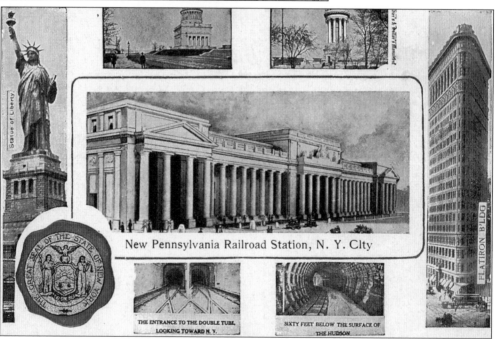

New Pennsylvania Railroad Station, N. Y. City

THE ENTRANCE TO THE DOUBLE TUBE, LOOKING TOWARD N. Y.

SIXTY FEET BELOW THE SURFACE OF THE HUDSON

The completed station appears in the central vignette of this view, with insets of the Hudson River tunnels appearing below. By 1917, the IRT extended service south along Seventh Avenue to Penn Station. In 1932, the IND opened its station at Eighth Avenue and West 34th Street, with underground access directly into the complex.

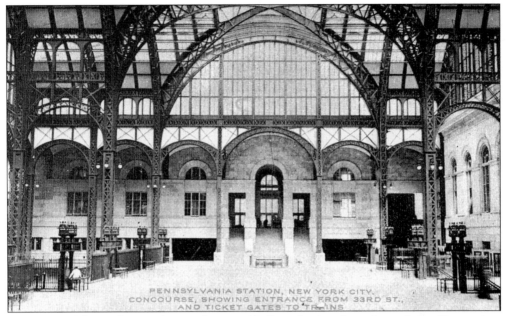

PENNSYLVANIA STATION, NEW YORK CITY.
CONCOURSE, SHOWING ENTRANCE FROM 33RD ST.,
AND TICKET GATES TO TRAINS

Just as their fellow subway riders on the east side lines deprive themselves of magnificent vistas by rushing through Grand Central, so the riders on the west side lines shortchanged themselves by not stopping to savor the delights of Penn Station. The vaulted glass-and-steel roof allowed sunlight to stream through the concourse, which (as at Grand Central) would be filled with humanity during rush hours.

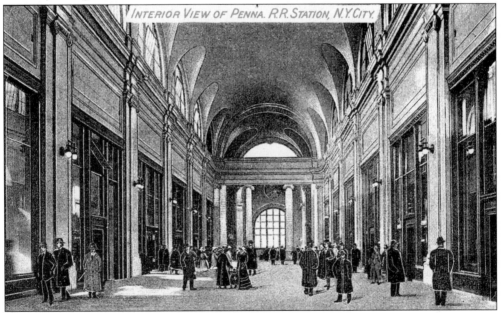

INTERIOR VIEW OF PENNA. R.R. STATION, N.Y. CITY.

The passengers from the commuter trains and the subway lines would emerge onto Seventh Avenue by passing through this arcade, lined with shops rivaling Fifth Avenue in their elegance. In Penn Station's demolition in 1966, the city, the country, and indeed the world lost an irreplaceable architectural gem. Lamenting its passing, one commentator observed, "Through it one entered the city like a god. . . . One scuttles in now like a rat."

117

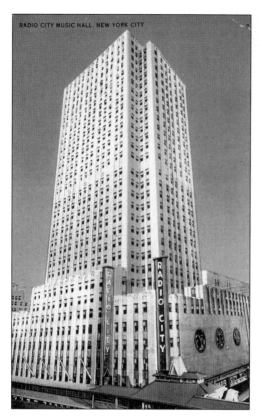

RADIO CITY MUSIC HALL, NEW YORK CITY

In the late 1920s, when the complex to be known as Rockefeller Center was being planned, a major consideration was the availability of mass transit—how to get the thousands of office workers to their jobs and, as important, how to get theatergoers to the huge theaters to be incorporated into the project. The Sixth Avenue elevated line already served the area from West 47th to 51st Streets, which was scheduled for development. Its station was right outside the door of the 6,200-seat Radio City Music Hall.

ROXY THEATRE NEW YORK

Farther up the Sixth Avenue tracks at 49th Street was situated a smaller theater originally named the RKO Roxy, after the entertainment entrepreneur Samuel Lionel Rothafel. Legal requirements forced a name change to the Century, a 3,700-seat house specializing in motion pictures. The theater was replaced in 1940 by an office building occupied by the U.S. Rubber Company. The figure in this view, walking the el tracks is, hopefully, a track inspector rather than a disgruntled straphanger.

Upon the clearing of the elevated to be replaced by the IND Sixth Avenue line, the Rockefeller Center interests had enough clout to have the usual street access to the subway platforms located within its buildings, leaving the sidewalks clear for pedestrians. In this view of the avenue cleared of the el, the subway entrance is recessed into the building line underneath the flagpoles to the left of the Radio City Music Hall marquee.

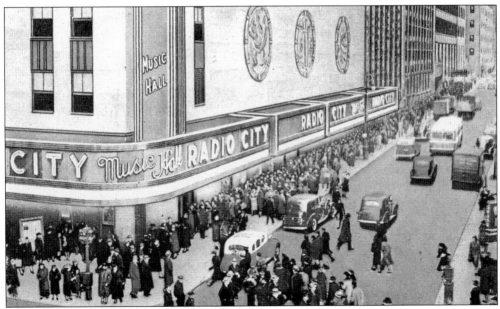

The line of theatergoers extends eastward along 47th Street as they wait patiently for the box office to open. Virtually all of these patrons would have ridden the subway to this popular destination.

Patrons attending performances at Radio City Music Hall have direct access to the theater from the subway station below. In fact, a box office is situated just outside the platform exit. Emerging into the foyer, the patron is presented with this magnificent sight.

GRAND FOYER, RADIO CITY MUSIC HALL
NEW YORK CITY

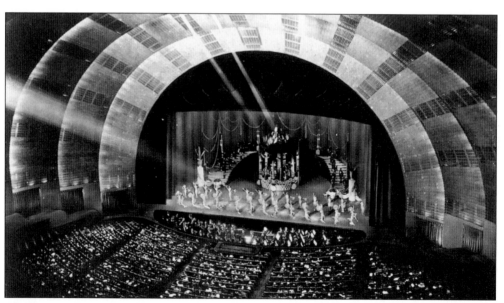

The theatergoer is immediately caught up in the awesome splendor of the house as he enters the auditorium. A full orchestra emerges on an elevator platform in front of the proscenium to announce the start of the stage show.

Since Radio City Music Hall is a mecca for tourists and natives alike, oftentimes the stage production has a New York City theme. Shown here is a representation of the Times Square theater district. Note the staircases and the arches labeled "Downtown" and "Uptown," symbolizing the city's vital network of underground transportation.

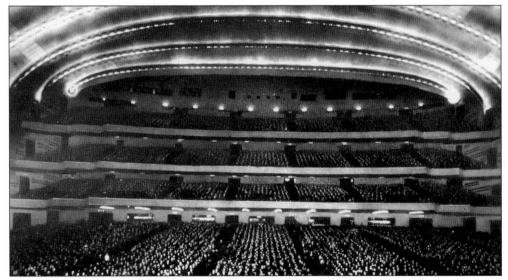

This view from the stage of Radio City Music Hall, looking out into the orchestra and its tiers of balconies, gives the viewer a sense of the enormous seating capacity—truly the world's largest theater and filled by an audience brought to the performance by the subway.

By a series of passageways connecting the buildings within Rockefeller Center, visitors can avail themselves of its multifaceted entertainment attractions. The passageways also give workers sheltered access to their offices. The hugeness of the complex, as originally conceived, is seen in this 1931 plaster model. Mercifully, the oval building in the center was never constructed.

Rockefeller Center, in all its majesty, is shown in this view looking west from Fifth Avenue. It stands as the ultimate in urban design, uniting transportation, commerce, retail shopping, and entertainment within a few square blocks in midtown Manhattan.

This view looks west from Church Street toward the Hudson River and New Jersey. The buildings served as the offices of the Hudson and Manhattan Railroad, which operated the Hudson Tubes. The tubes terminated beneath the buildings. Riders would pass through the complex to connect with the elevated (foreground), which ran north and south on Church Street.

This artist's model shows the World Trade Center complex. The twin towers and four satellite buildings of the complex replaced the office buildings of the Hudson and Manhattan Railroad, which were razed in 1966. By the time of the construction of the twin towers, two subway lines had replaced the el, thereby giving riders of the Hudson Tubes (now PATH) sheltered access to continue their commute by subway throughout Manhattan and the outer boroughs. The buildings of the World Trade Center were constructed in the 1970s and were destroyed in the terrorist attacks of September 11, 2001.

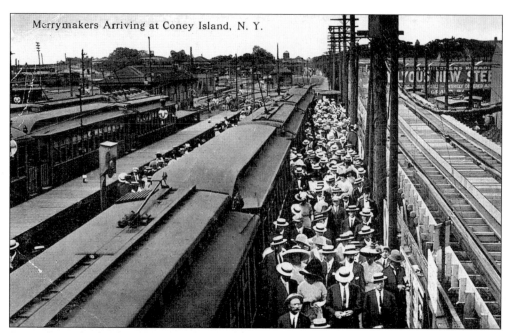

Merrymakers Arriving at Coney Island, N. Y.

Since the mid–1800s, Coney Island, at the southern extremity of Brooklyn on the Atlantic Ocean, has been the favorite seaside resort of the teeming masses of New Yorkers. Originally, access to this island was exclusively by ferryboat. After construction of viaducts and electrification of surface rail lines, the migration to the resorts and amusement parks multiplied, as can be seen in this view.

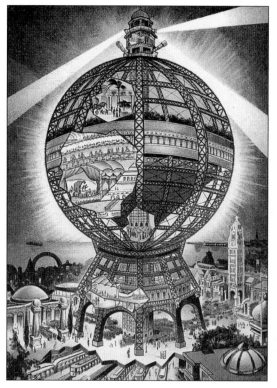

Among the attractions was this planned giant globe in which exhibitions and theatrical performances were to be staged. Access to the behemoth was to include underground transportation, as envisioned in the cutaway. This planned globe was a giant scam, a hoax that brought in thousands of investment dollars to the promoter, with not the turning of a single shovelful of dirt.

By far the most visible transportation hub in Manhattan was located at the foot of the Brooklyn Bridge near New York City Hall. While the hubs at Grand Central, Times Square, Rockefeller Center, and others were isolated from street traffic, these thousands of Brooklynites streaming in and out of Manhattan were exposed to the congestion and to the elements every working day.

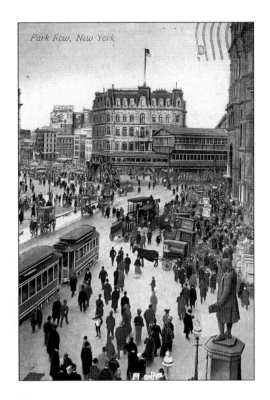

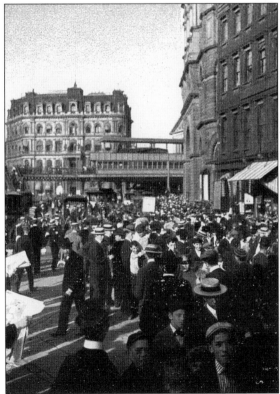

This view, as well as the scene above, are dominated by the Staats Zeitung Building, dated from *c.* 1910. The upper view, with a statue of Benjamin Franklin in the foreground, was taken from perhaps the second floor of a neighboring building; the lower view shows a goodly percentage of the estimated 50,000 commuters who use the subway, els, and cable and electric streetcars that were concentrated within these few city blocks.

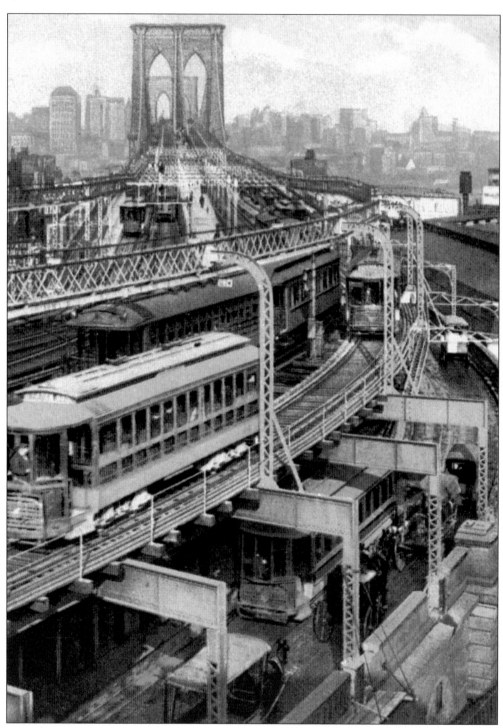

The clean classic lines of Brooklyn Bridge were defaced almost immediately after its 1883 opening by the superstructures erected for cable cars and overhead trolley lines. Substantial pedestrian and horse-drawn vehicle traffic added to the rush-hour press of Brooklynites getting to their jobs in lower Manhattan, seen in the distance behind the bridge towers.

It took almost 50 years to rid the Brooklyn Bridge of the streetcars that crowded out the pedestrian and private vehicles that the bridge was constructed to accommodate. The vital mass-transit facilities are now hidden away in subway tunnels under the East River. Whatever improvements there will be in how New York's eight million residents and additional millions of visitors get around the city, the subway will continue to play an indispensable role.

INDEX

Beach, Alfred Ely, inventor of pneumatic subway, 37

Belmont, August, financier of subway, 37

Brooklyn-Manhattan Transit Corporation (BMT), subway system, 7, 36, 52

Brower, Abraham, coach maker, 10

Cooper, Peter, inventor-industrialist, 30, 97

Cropsey, Jasper F., artist-designer of el stations, 24

Epps, Moses, subway powderman, 38

Forney, Matthias, locomotive engineer, 19

Fulton, Robert, inventor of steamboat, 16, 72

Greathead, Sir James Henry, construction engineer, 63

Guardian Angels, civilian safety patrol, 58

Guastavino, Raphael, architect, 74

Harvey, Charles, inventor of elevated system, 7, 19, 20

Haskin, DeWitt Clinton, construction engineer, 61

Hecla Iron Works, manufacturer of kiosks, 37, 50

Heins & LaFarge, designers of subway entrances and platforms, 49, 50, 69, 70

Hudson and Manhattan Railroad (Hudson Tubes), 17, 18, 61, 62, 63, 65, 66, 67, 68, 77, 81, 116, 123

Independent Rapid Transit Railroad (IND), 7, 40, 52, 85, 116, 119

Interborough Rapid Transit (IRT), subway line, 7, 37, 38, 41, 50, 52, 54, 55, 62, 64, 72, 73, 74, 76, 85, 90, 106, 107, 113, 116

Keaton, Buster, film actor, 87

Lo-V, subway cars, 55, 79

McAdoo, William Gibbs, financier of Hudson Tubes, 61

Meeker, Ezra, historian, 14

Metropolitan Transportation Authority (MTA), 50, 51, 82, 83

Monroe, Marilyn, film actress, 88

New York & Harlem Railway, on city streets, 12

Outcault, R.F., cartoon artist, 6, 15

Parsons, William Barclay, engineer, 54

Potter, Henry C., Episcopal bishop, 45

Quill, Michael, labor leader, 57

Schiff, Jacob, philanthropist, 95

Sprague, Frank J., locomotive engineer, 19

Stevenson, John, coach maker, 12

Stuyvesant, Peter, governor of New Amsterdam, 23, 71

Subway Tavern, 45

Swanson, Gloria, film actress, 87

trams, 56

triplex railroad cars, 36

Tweed, William M., political boss, 20

World's Fair (1939–1940), 51, 90